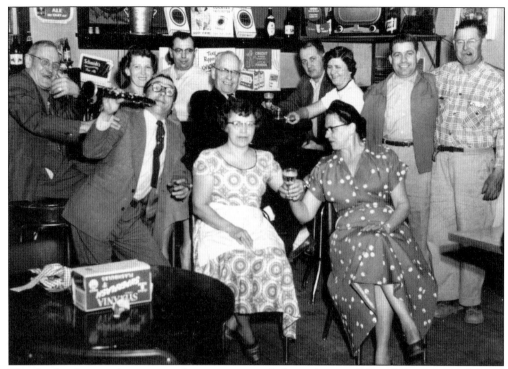

This book, along with its spirit of community, is dedicated to my "Nana" Ann Messenlehner, whose love, generosity, and maternal guidance are beyond my ability to comprehend, and to my late grandfather Louis Messenlehner, the most talented musician one could know. Together, they built a foundation of true family as lifelong residents of Northampton.

From humble beginnings on 10th Street, they moved to 1637 Main Street in 1948 and opened Messner's Bar and Luncheonette, where my father, Stephen, and mother, Joan, met during his lunch break. It was also where "Pop-Pop" fulfilled his dream of owning a music store—Melody Mart, as it was known—after retiring from years at Bethlehem Steel. It was where I opened "All Things Framed" in 1996. And finally, it was where this book was compiled and written with the helping hands of many selfless townspeople.

Under the watchful and gracious eyes of Nana, I found what tradition and family are all about in a small, neighborly town. With the lifelong tutelage of my patient and able parents, who let my brother Bobby, sister Wendy, and me occasionally trip, but never fall, and the priceless guidance of my aunt Nancy and uncle Jim, I grew and shared as I could. As my late uncle Myron Radio taught me on all those hot summer days chucking A-Treat soda, work does not have to be humorless; it just has to get done. It is what my nephew Bobby Jr. and nieces Samantha and Lizzie will find out as they journey. It is just what many a son and daughter are taught as they grow up in Northampton.

Most of all, I remember my uncle Tony, who left this world far too soon—a man who lived 100 admirable lifetimes in 22 years. Though I was only four years old when he died, such was his presence in that short time that every day it leaves me realizing that I surely missed out on one great show. Certainly, this was discovered by all who knew him.

Thank you, Nana and Pop, again for building the "home" that you did. I could not imagine life without it."

The photograph above was taken in 1948 during a night relaxing at Messner's. From left to right are the following: (sitting) "Nana" Ann Messenlehner and Mabel Longenbach; (standing) Chipper Gillespie, Elsie Sodl, Bill Sodl, "Pop-Pop" Louis Messenlehner, Warren Longenbach, Eddie Klucharich, Nellie Klucharich, and two unidentified cement workers stopping by for a "cold one."

Images of America
NORTHAMPTON

Anthony S. Pristash

Copyright © 2004 by Anthony S. Pristash
ISBN 0-7385-3615-6

First published 2004

Published by Arcadia Publishing,
Charleston SC, Chicago IL, Portsmouth NH, San Francisco CA

Printed in Great Britain

Library of Congress Catalog Card Number: 2004104020

For all general information, contact Arcadia Publishing:
Telephone 843-853-2070
Fax 843-853-0044
E-mail sales@arcadiapublishing.com
For customer service and orders:
Toll-free 1-888-313-2665

Visit us on the Internet at www.arcadiapublishing.com

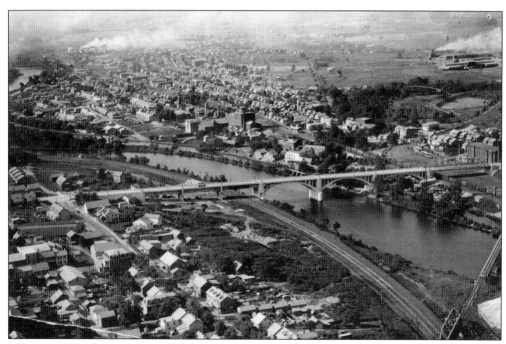

This c. 1925 bird's-eye view of Northampton looks north. The two cement mills in the distance are Lawrence Portland Cement (left) and Atlas Plant No. 4 (right). The Northampton Brewery stands prominently in the center.

Contents

Acknowledgments 6

Introduction 7

1. The Three Villages 9

2. Cement Is King 31

3. The Town Known as Northampton 53

4. Uptown 85

5. Our Townspeople, All Neighbors 105

Acknowledgments

I would like to gratefully acknowledge the generous, overwhelming contributions and boundless knowledge of both Harold Smith, president of the Northampton Historical Society, and Edward Pany, local historian and curator of the esteemed Atlas Cement Museum. The adventure of working alongside these two fine gentlemen was certainly worth the price of admission. Between the two of them, the stories about each photograph and its location would, thankfully, never seem to end. I truly believe my local history IQ went up 20 points just sitting by those two.

I also want to wholeheartedly thank Mayor Thomas Reenock for his involvement and good-natured push to keep this project going forward. As the consummate man-about-town, he relished all challenges to find that elusive photograph or two I needed to complete a story. Thanks also go to the members of the Northampton Historical Society, who provided all the images in this book, except where noted. The education I received from them is certainly worth passing on to others.

I am grateful especially to all additional photograph contributors, including Marty Fella Jr., a fellow businessman also carrying on the family tradition and one who sure knows how to fit 25 hours of photography into a 24-hour day; Ralph Hoffman; Naomi Halperin; the *Morning Call*; David Rank Jr.; Robert Mentzell; Art Brown; Frank Keller Jr.; Brian Bartholomew; Jack Guss; Richard Wolfe; Randi B. Sage; John Pavis; Frank Yandrisevits; Harold Schisler; Stephen Luisser; Dale and Susan Sadler; James Benetzsky; Jack DeLabar; Stephen Toth; Peter Krywczuk; and certainly Gene Zarayko, borough manager. Thanks also go to Connie for indulging me to the point of "glazing over," while I bounced countless ideas around. I appreciate all that every one of you brought to this project, especially your pride in this community. To all of those who came before us, leaving us strong foundations with which to build our future, we could not forget. Thank you.

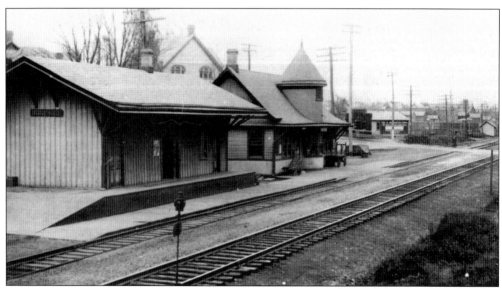

Looking south, this view shows the 1905 Siegfried train station and baggage house. Today, the station houses the Northampton Historical Society and many of the town's historical treasures.

INTRODUCTION

If you are looking for us on the globe, we are at 79.29 degrees west longitude and 40.41 degrees north latitude. If you want to drop us a line, the zip code is 18067. Although these seem like just numbers, they will get you to a place that more than 8,700 people proudly call home—Northampton, Pennsylvania.

With a rich history dating from 1740, when Hugh Wilson's settlement was established, Northampton has gracefully evolved and grown into the borough of today. What was once the land of the Lenni Lenape was later developed by Irish settlers farming the rich soil. The story of the region continued through the expansion of settlements and the formation of hamlets with names like Laubachsville, Siegfried, Newport, and Stemton to their consolidation in 1902 into the borough of Alliance. In 1909, the area finally became Northampton, and its story continues to write itself today.

If a picture really is worth a thousand words, the images in this book surely speak more than the 200,000 words required of them. This volume will take you on a nostalgic look back at the town, from the dawn of the 20th century through the glory years of the expansive, world-renowned cement industry. You will then take a trip through the four wards of Northampton, with a special detour uptown, where residents could meet all their shopping needs within a few blocks. Finally, you will meet some of those who built this town into a great place to work, live, and serve others—a place that residents are proud to call home.

Many of these photographs have rarely seen the light of day. It is with great enthusiasm that they—and the memories they revive—are shared with you in this trip back in time.

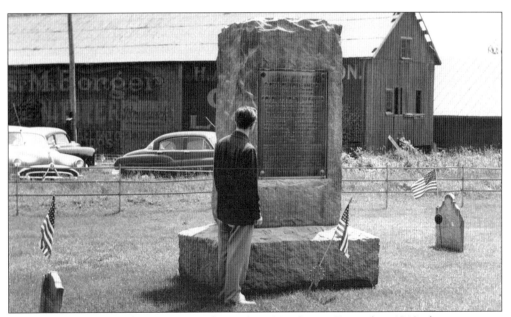

The Col. John Siegfried Monument is located on 21st Street. Erected in 1913, the monument commemorates the deeds of our Revolutionary War hero and local settler. The Miller Coal and Lumber Yard is present in the background. (Courtesy of Carol Simcoe.)

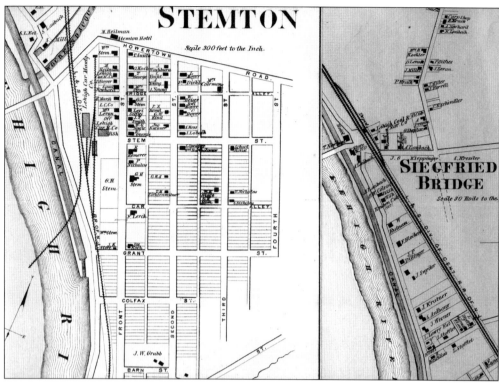

This 1874 Stemton, Siegfried Bridge, and Newport map was published by the D. G. Beers Atlas Company of Philadelphia.

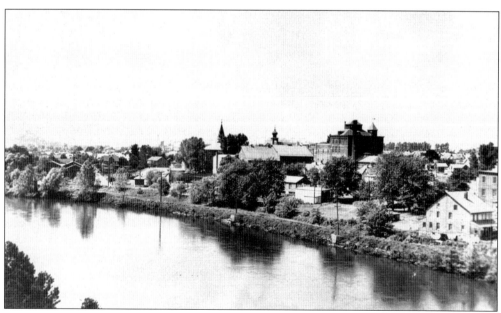

In this mid-1930s northeastward view from the Northampton-Coplay Bridge, the Northampton Brewery is just to the right of the center. The Adam Laubach House is visible in the lower right-hand corner.

One
THE THREE VILLAGES

The Siegfried Bridge is shown in this 1903 westward view. Built in 1828, the covered toll bridge was the main thoroughfare to Cementon. On the right is Col. John Siegfried's tavern. Prior to the bridge, Colonel Siegfried and his heirs also ran a ferry operation from here.

This image, dating to 1899, is the oldest known photograph of the Wilson Blockhouse. Constructed in 1756, the blockhouse was built at the urging of Benjamin Franklin as protection from Native American attacks.

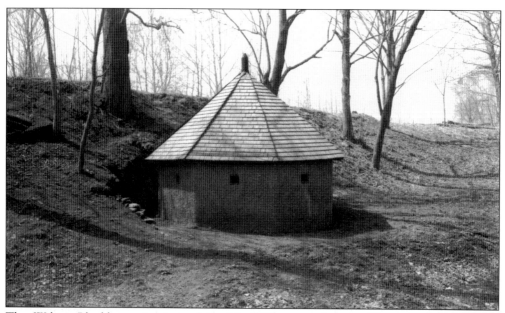

The Wilson Blockhouse is pictured in this 1959 eastward view. The mound behind the blockhouse was built by the Atlas Cement Company when its railroad came into the area. Moved in 1984, the blockhouse is now located at the Northampton Borough Community Park on Laubach Avenue. (Courtesy of Fella Studios.)

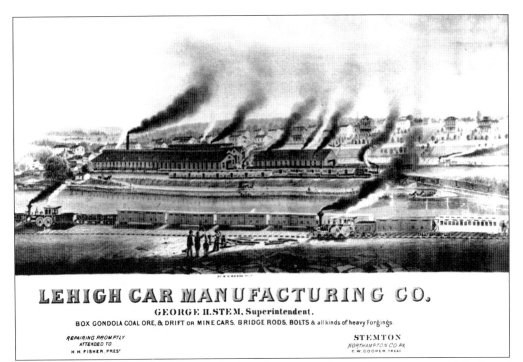

Located to the rear of the former Clyde shirt factory, on the northwest corner of Ninth and Main Streets, the Lehigh Car Manufacturing Company was one of the area's largest employers. Opened in 1867, the company manufactured spring and farm wagons, as well as train cars.

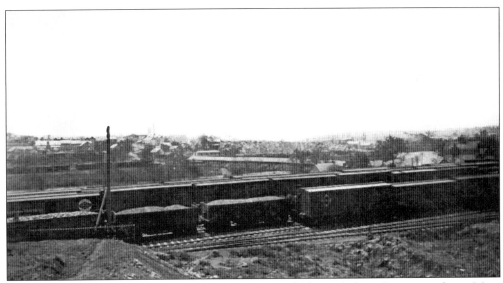

This view, looking west, shows the old Stemton rail yards, located along the river on lower Main Street. Note the covered bridge to Coplay in the background. (Courtesy of Ralph Hoffman.)

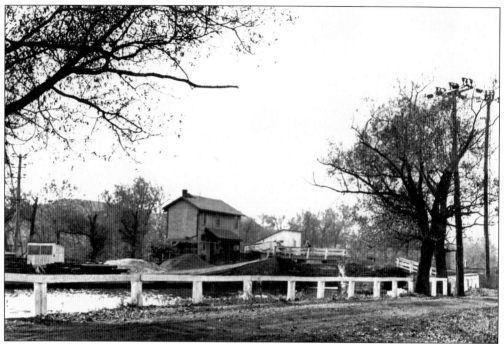
Canal Lock No. 35 and the lock tender's house are seen c. 1905, behind today's Hungarian Hall on Canal Street.

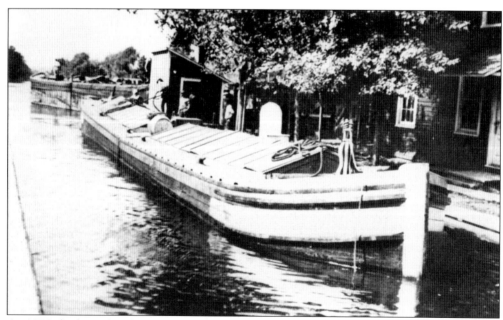
A 1907 Lehigh Coal and Navigation Canal boat is pictured here. Mule-drawn boats carried coal from the mines to local stops all the way to Philadelphia. Located between the Lehigh River and Canal Street, the canal aided in the area's transportation of rich agricultural products and newly found coal and cement rock. (Courtesy of Ralph Hoffman.)

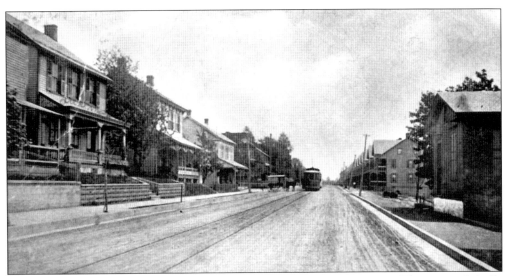

Looking south from 10th Street, this view reveals c. 1905 Main Street. The store of A. D. Borger is located next to the horse-drawn wagon to the left. The Stemton-Coplay Bridge was accessed just to the right of the trolley. (Courtesy of Ralph Hoffman.)

The A. D. Borger store was located at the northeast corner of Ninth and Main Streets when this c. 1905 photograph was taken. Owner Alfred Borger sold general merchandise and groceries. The wagon at the lower right is the same one shown in the previous photograph. This building was previously the company store for the Lehigh Car Manufacturing Company, which would have been located just across the street.

13

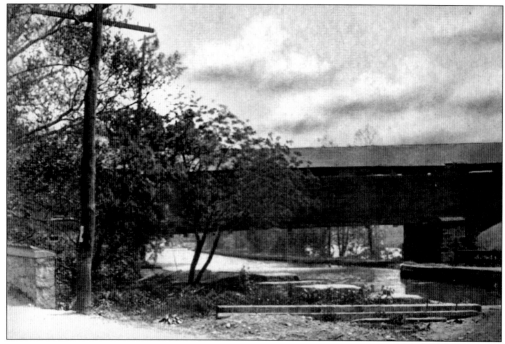

Spanning the Lehigh River at Ninth Street, the Stemton-Coplay Bridge was an important river crossing serving both communities. The Lehigh Canal appears in the foreground c. 1856. (Courtesy of Ralph Hoffman.)

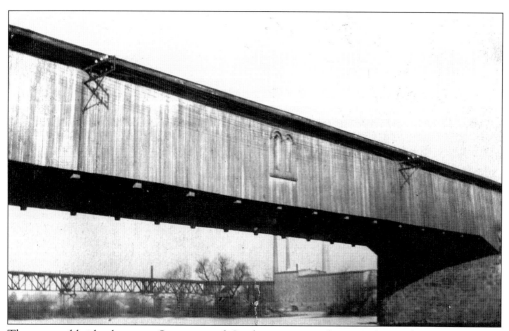

The covered bridge between Stemton and Coplay is seen in this c. 1856 southward view, with the train trestle in the background.

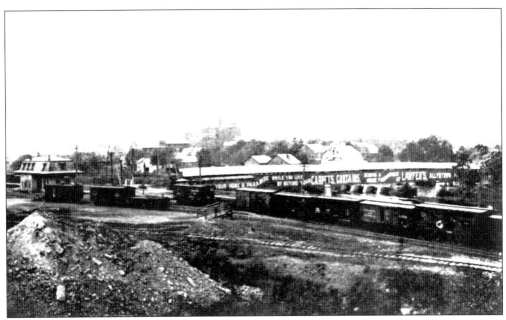

Looking east from Coplay, this view shows the Stemton-Coplay Bridge. The Northampton Brewery dominates the skyline, with the Lehigh Valley Rail Road in the foreground, c. 1905. (Courtesy of Ralph Hoffman.)

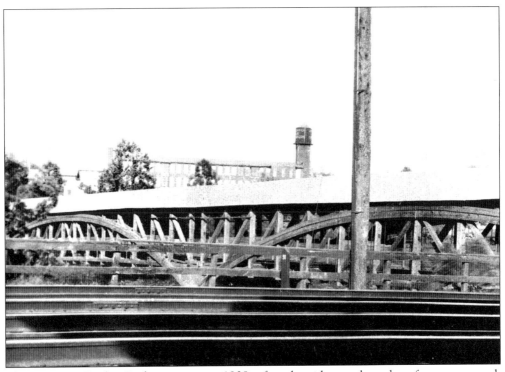

The Stemton-Coplay Bridge appears c. 1908, after the side panels and roof were removed. (Courtesy of James Benetzky.)

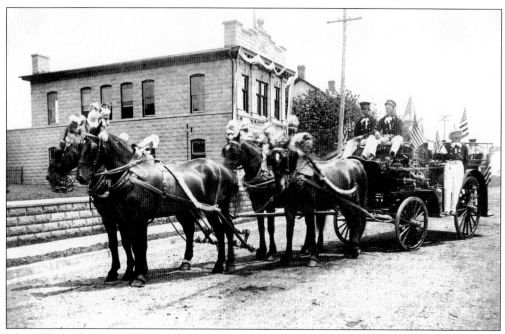

This Alliance horse-drawn fire truck prepares for a parade in 1905. (Courtesy of Edward Pany.)

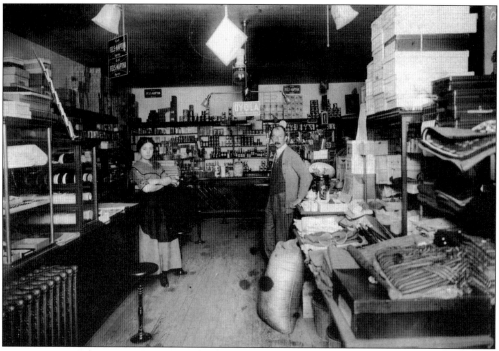

Hunt's Store, located at Seventh Street and Washington Avenue, sold general merchandise and fabric. Note the gaslights and the stools bolted into the floor, which were used as customers shopped for fabric c. 1905.

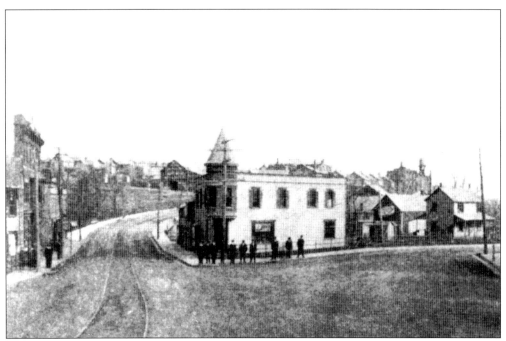
This southward view of Main Street at Laubach Avenue dates from 1905.

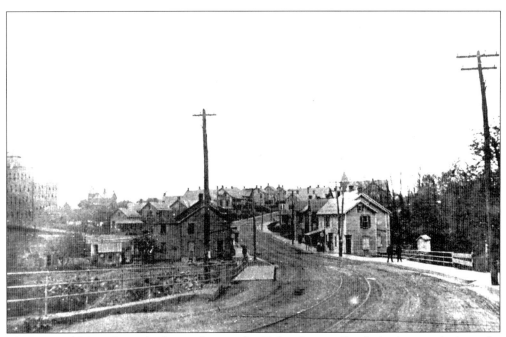
This view of Main Street looks north over the Hokendauqua Creek, back toward where the previous photograph was taken. The Northampton Brewery figures prominently to the left.

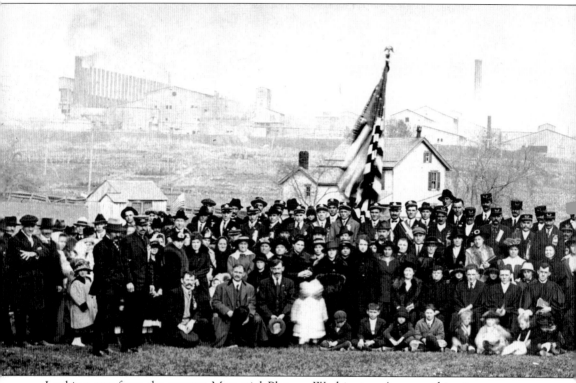
Looking east from the present Memorial Plot on Washington Avenue, this view captures a c. 1910 Remembrance Day gathering. Atlas Cement Plant No. 4 and the John and Ida Smith

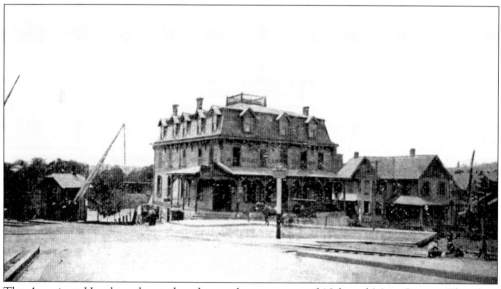
The American Hotel was located at the northwest corner of 10th and Main Streets. Theodore Roosevelt reportedly stayed here while on a visit to Atlas Cement in 1908. Note the railroad crossing gate and the watchman's house in the foreground. (Courtesy of the *Morning Call*.)

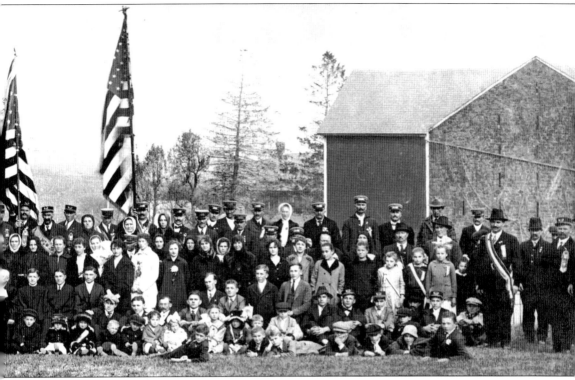

house and barn appear in the background. The borough municipal offices now occupy the site of the house. (Courtesy of Robert Mentzell.)

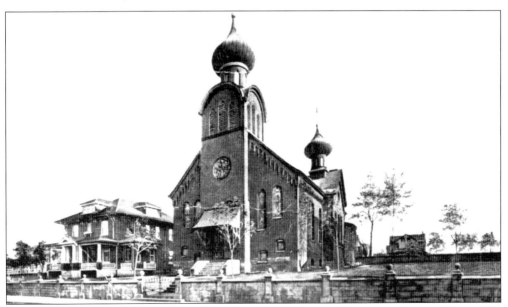

St. John the Baptist Greek Catholic Church, at 1343 Newport Avenue, is shown with a newly built rectory in 1913. Founded and built in 1900 on land purchased from Samuel Laubach, it was the first Catholic church in Northampton, still Newport at that time. (Courtesy of Peter Krywczuk.)

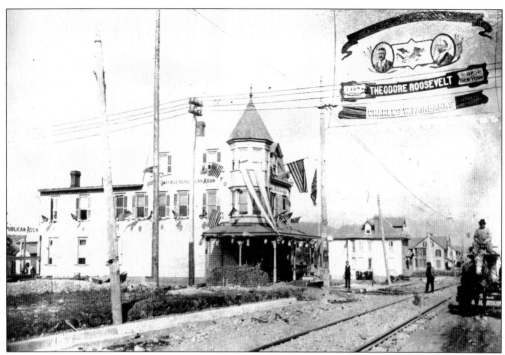
The Garfield Republican Association was located at the northwest corner of 15th and Main Streets in 1903, in a structure also known as the Diamond Building. (Courtesy of the *Morning Call*.)

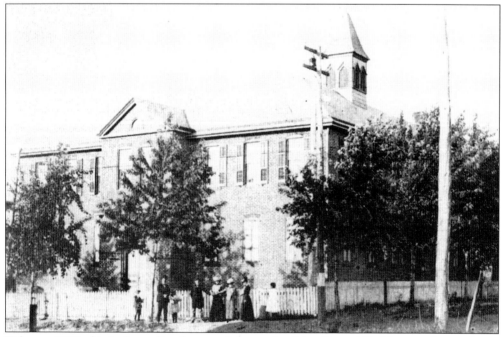
Taken *c.* 1903, this is the earliest known photograph of the Central Building, at the northeast corner of 15th and Main Streets. Opened as the Brooklyn School in the 1890s, the Alliance School was the area's first high school. (Courtesy of Ralph Hoffman.)

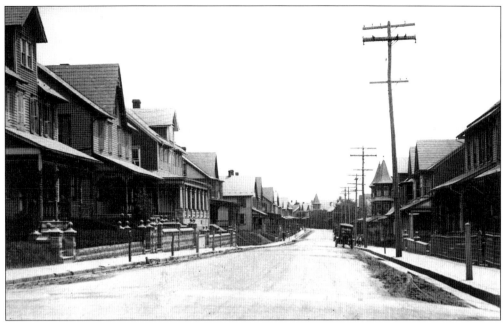

This c. 1903 view looks south on Washington Avenue from 19th Street. (Courtesy of the *Morning Call*.)

At 1516 Main Street, the municipal building was built in 1908 for $16,000 and housed the Central Fire Company and borough offices. (Courtesy of the *Morning Call*.)

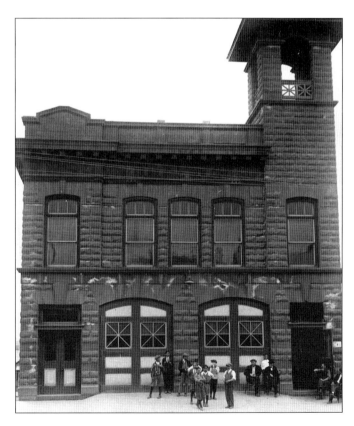

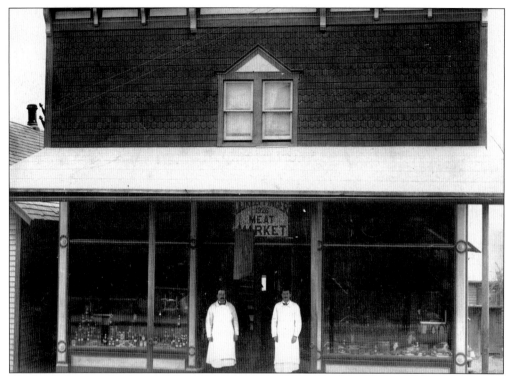

Kleppinger's Meat Market, photographed c. 1903, was located at 1926 Main Street. It later became the site of the M&N drugstore. Charles Moses Schisler (left) is pictured here with John J. Kleppinger. (Courtesy of Harold Schisler.)

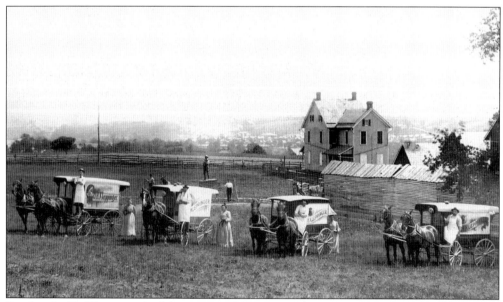

Butcher J. H. Kleppinger's delivery wagons are seen here c. 1903. The Kleppinger farm and slaughterhouse were located on West 27th Street. In the background, notice the Dragon cement plants.

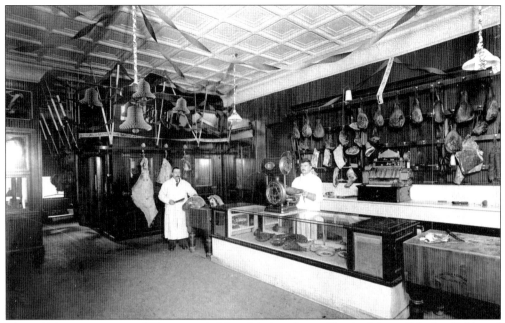
This 1903 interior view of Kleppinger's Meat Market shows Charles Moses Schisler (left) and John J. Kleppinger.

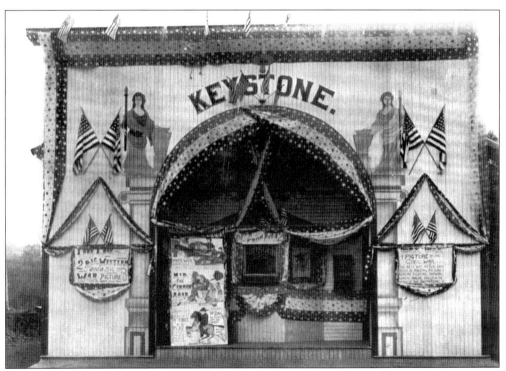
The Keystone, at 18th and Main Streets, first opened in 1908. Late in the second decade of the 20th century, the theater was sold to the Lerners, who subsequently used the land for a department store. (Courtesy of Richard Wolfe.)

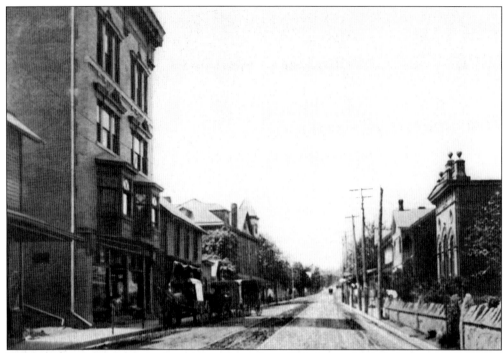

This *c.* 1905 northward view shows Main Street from 20th Street. Miller's (a department store) is immediately to the left, and the Cement National Bank of Siegfried is on the right. (Courtesy of Ralph Hoffman.)

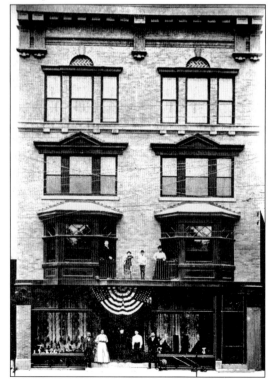

Miller's was built in 1905 at 2010–2012 Main Street by Henry A. Miller. Pictured on the balcony are, from left to right, Henry A., R. Kline, and Hillard Miller and his wife, Lizzie. At the lower-level front door are their employees.

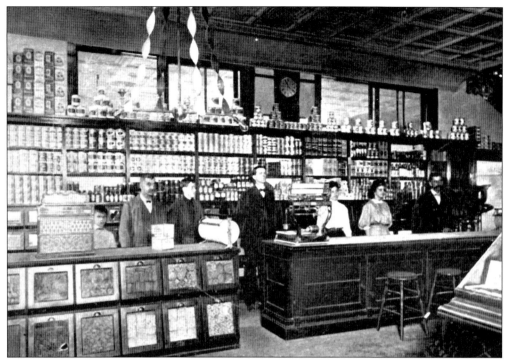

The Miller's grocery department appears here in 1907. H. A. Miller, the tall gentleman in the center, is flanked by his employees.

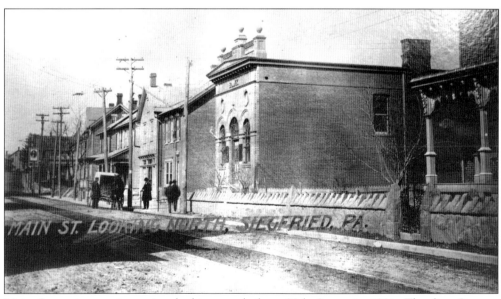

Main Street is seen in a view looking north from 20th Street in 1901. The first Cement National Bank of Siegfried, which opened in 1899, is in the foreground. Visible to the far left is the Mount Vernon Inn.

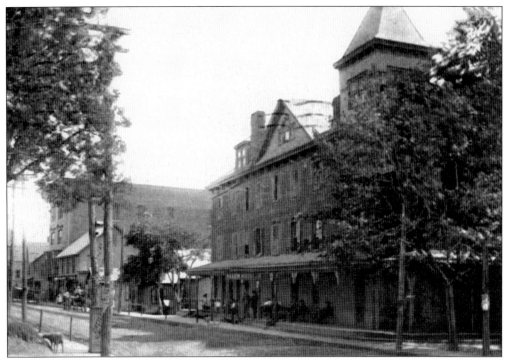

This southward view shows the Allen House, located at the southwest corner of 21st and Main Streets, in 1902. It was originally opened in 1872 by John H. Kleppinger, who later bequeathed it to his son John J. Note the wraparound porch. The Miller Building can be seen to the left.

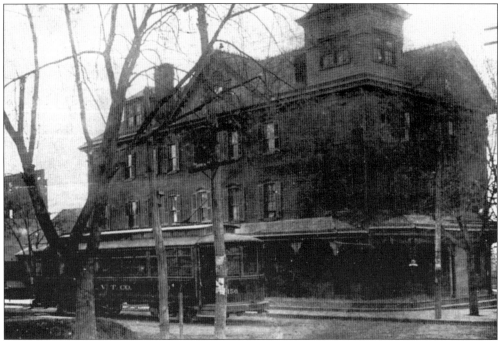

The Allen House, seen here in 1907, continued to be a popular boardinghouse and restaurant. Note the newly introduced transportation—the trolley—on the Main Street side.

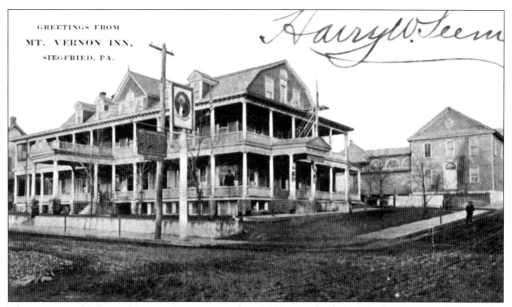

The renowned Mount Vernon Inn, pictured c. 1902, was built by Noah Weiss in 1898 at the northeast corner of 21st and Main Streets. An accomplished woodworker, Weiss produced many beautiful, intricate, and treasured wood carvings using just a jackknife. To the right is a rare view of Curio Hall, where Weiss carved and displayed his work. (Courtesy of Ralph Hoffman.)

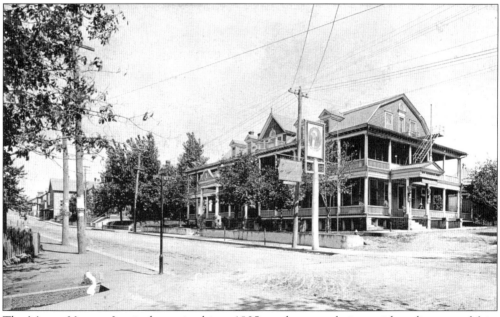

The Mount Vernon Inn is shown in this c. 1905 northeastward view, with a glimpse up Main Street. The attached barn, partially visible to the right, housed a milk bar, where fresh milk was served directly from a cow Weiss had carved out of wood. (Courtesy of Ralph Hoffman.)

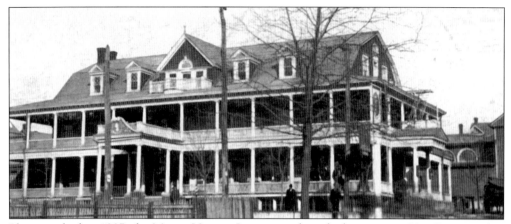

Photographed in 1907, the Mount Vernon Inn is seen from farther west on 21st Street, with a portion of Curio Hall to the far right. The inn was modeled after George Washington's Mount Vernon estate in Virginia. (Courtesy of Ralph Hoffman.)

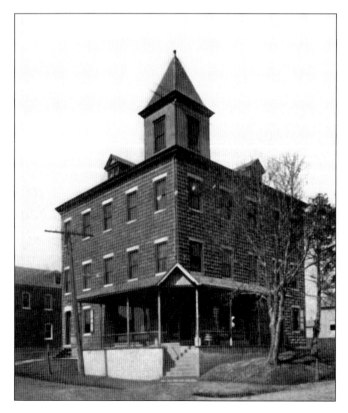

The Odd Fellows building was located at the northeast corner of 21st Street and Washington Avenue. It was built in 1904–1905, with the first meeting of Siegfried Lodge No. 1025 held on April 7, 1905. It was torn down in 1955. (Courtesy of Ralph Hoffman.)

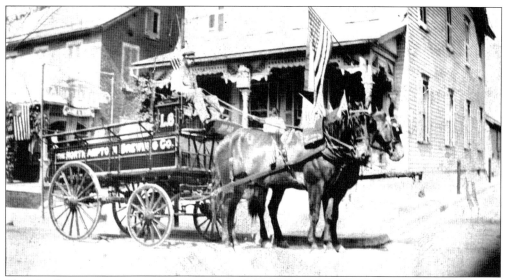

The Northampton Brewing Company's first delivery wagon is pictured c. 1904 in front of the Alliance Hotel at 2332 Main Street. Producing Tru-Blu beer and ale, the company owned a number of local hotels, which also sold the brewery's product. (Courtesy of Edward Pany.)

The Diebert House, at 2167 Main Street, is shown c. 1905. The shop of harness maker Jerry L. Diebert is to the right. Note the kerosene lamppost in front of the house. (Courtesy of Joe Yurish.)

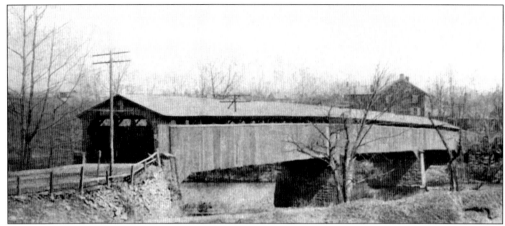

This c. 1902 photograph of the Siegfried Bridge was taken from the west bank of the Lehigh River. The Siegfried Tavern is visible in the background. (Courtesy of Ralph Hoffman.)

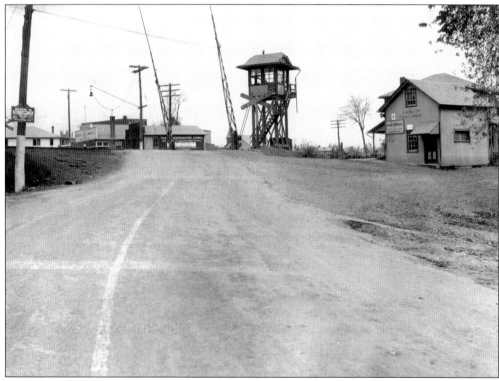

A visitor would catch this first sight of Siegfried, Pennsylvania, upon exiting the covered bridge traveling eastbound c. 1905. Miller Coal and Lumber is to the right.

Two
CEMENT IS KING

It is with great pride in our cement heritage that this chapter is dedicated to the many men and women who worked in the cement mills of Northampton, and to Edward Pany, the dedicated curator of the Atlas Cement Museum, keeper of that flame.

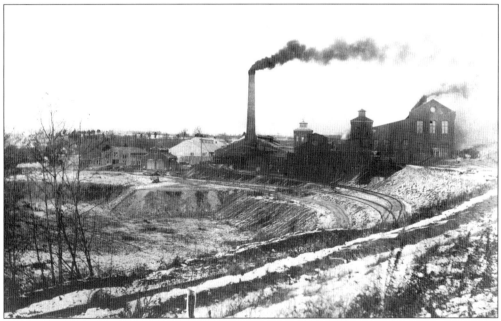

Plant No. 2 is seen here in 1902, in the oldest known photograph of the Atlas Cement Company plants. Started in 1895 by founder Jose Navarro, Northampton's Atlas Portland Cement Company soon became the world's largest Portland Cement company. (Courtesy of Edward Pany.)

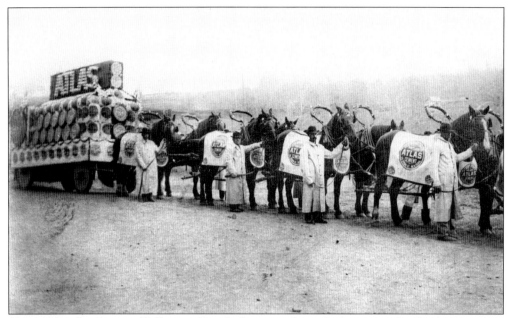
The 1903 Atlas Cement Halloween Parade float was drawn by horses used to hauling cement-laden wagons during plant operations. (Courtesy of Edward Pany.)

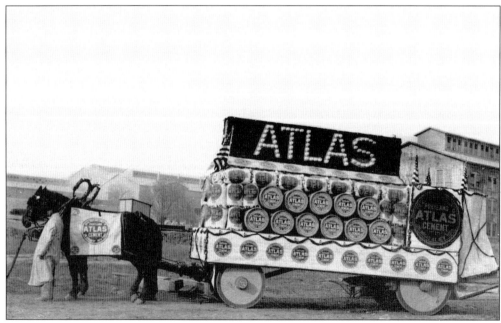
A horse-drawn wagon readies for the Halloween parade in 1903. Plant No. 2 can be seen in the background. (Courtesy of Art Brown.)

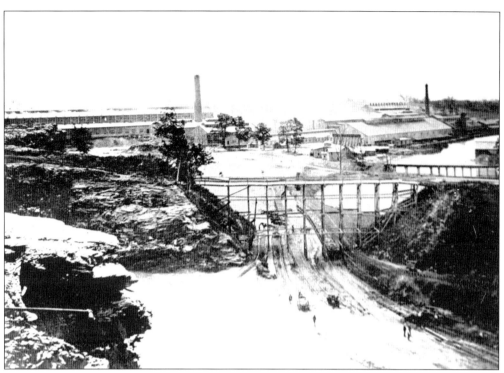
This 1908 photograph shows Quarry Hill at the Atlas Cement Company. Note Plant Nos. 2 and 3, with their horse-drawn, stone-filled carts. (Courtesy of Edward Pany.)

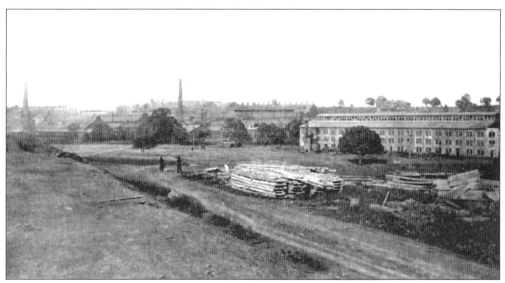
Plant Nos. 2 and 3 are pictured in this 1907 image. (Courtesy of Art Brown.)

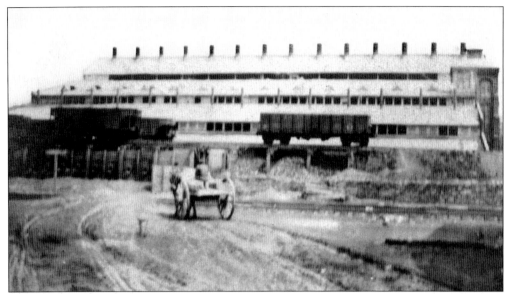

A horse-drawn cart is shown at Atlas Plant No. 2 in 1910. Over 400 horses were used at the plant at that time. (Courtesy of Edward Pany.)

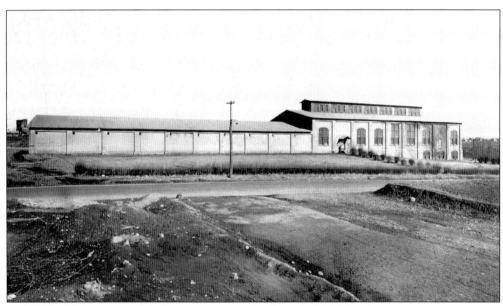

The Atlas Bag Factory and Printery, photographed c. 1905, was where dozens of men and women produced cloth cement bags and printed all Atlas stationery. Today, the building houses the Northampton Memorial Community Center. Note that Laubach Avenue is still a gravel road. (Courtesy of Edward Pany.)

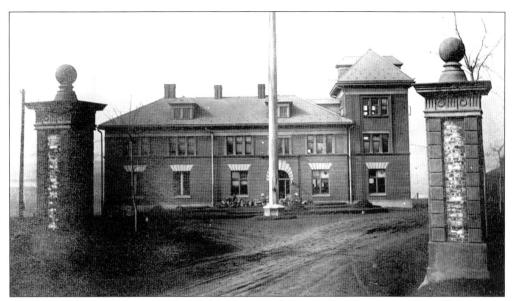

This 1910 photograph shows the Atlas Cement Company headquarters. The pillars in the foreground still stand today on the 1200 block of Northampton Avenue. Company agents attracted thousands of future employees from many European countries. These new Americans brought with them a strong work ethic and rich cultural heritages that were assimilated into Northampton, "the Cement Borough." (Courtesy of Edward Pany.)

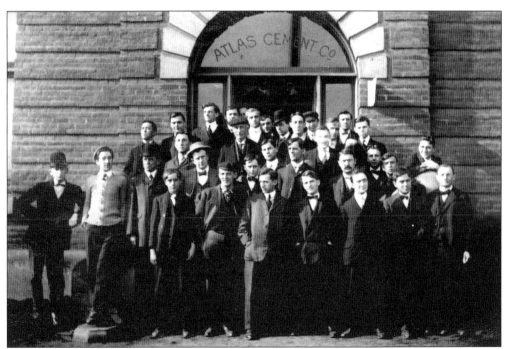

Members of the Atlas Cement Company office staff pose for this 1910 photograph. The office was located on the Atlas site below today's Northampton Avenue. More than 5,000 employee records were maintained at this site when it was the largest cement plant in the world. (Courtesy of Edward Pany.)

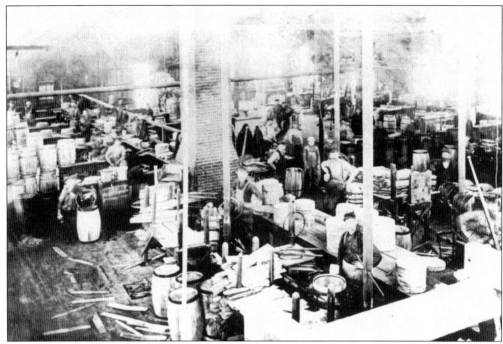

The cooperage shop, photographed in 1902, employed some 125 employees who made wooden cement barrels. Each barrel held 376 pounds of cement. The barrels were later replaced by the cloth bags made in the bag factory and printery on Laubach Avenue. (Courtesy of Edward Pany.)

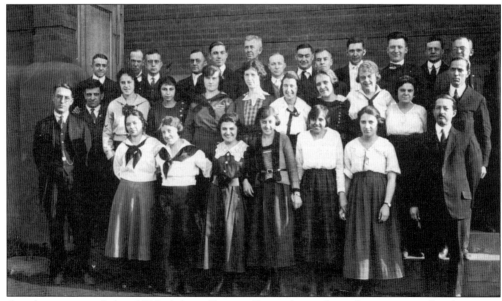

Another group of the 1910 Atlas office staff was located at the company headquarters. (Courtesy of Edward Pany.)

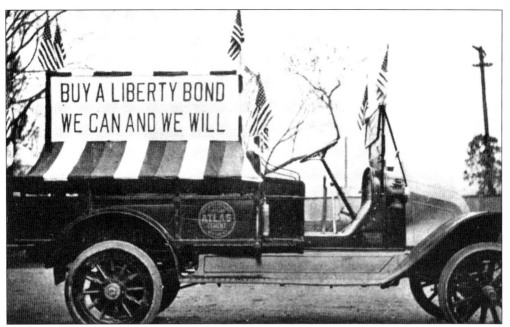

The 1917 World War I liberty bond drive used an Atlas Cement Company Mack truck. (Courtesy of Edward Pany.)

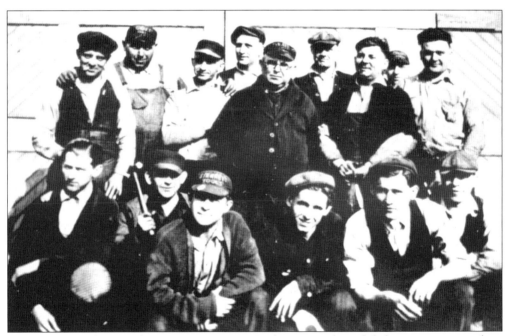

Atlas machine shop employees pose in 1928. With great pride and dedication, crews such as these produced cement for a growing country and great projects such as the Panama Canal, the Empire State Building, Rockefeller Center, the Hoover Dam, and the roads and infrastructures of many states and cities. (Courtesy of Edward Pany.)

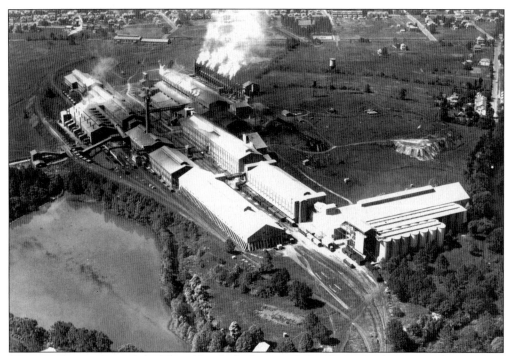

This aerial view shows Atlas Plant No. 4, the largest of the plants. Looking east, the view was taken on September 14, 1940. Currently, this is the site of the Northampton Area Senior and Junior High Schools and Al Erdosy Field. Note the bag factory and printery, today's Northampton Memorial Community Center, at the upper left and the yet undeveloped residential land at the upper right. (Courtesy of Edward Pany.)

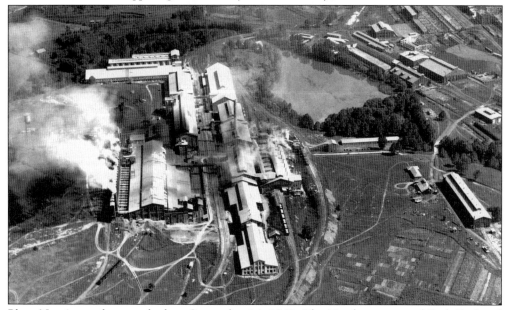

Plant No. 4 was photographed on September 14, 1940. The Northampton and Bath Railroad locomotive shop can be seen in the middle right of this northeastward view. (Courtesy of Edward Pany.)

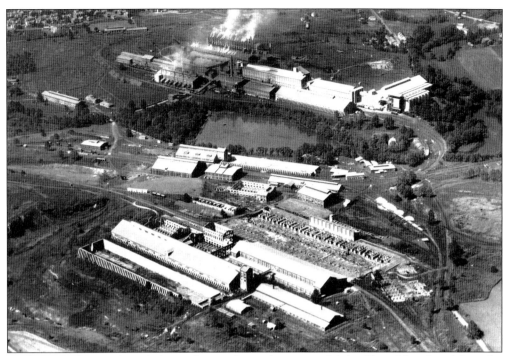

Looking northwest, this 1940 aerial view shows the ruins of Atlas Plant Nos. 2 and 3 in the foreground. As those facilities were antiquated by better production methods, the more modern Plant No. 4, seen to the top, continued to serve the cement-producing needs of the company. (Courtesy of Edward Pany.)

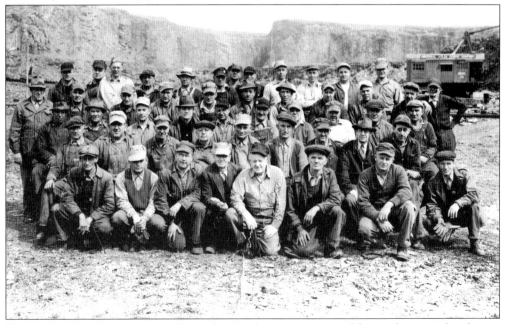

The 1948 Atlas Quarry crew works in the Northampton quarry. Of special note is the electric Bucyrus shovel in the upper right section of the photograph. It is one of three shovels Atlas used to replace the steam shovel and manual labor.

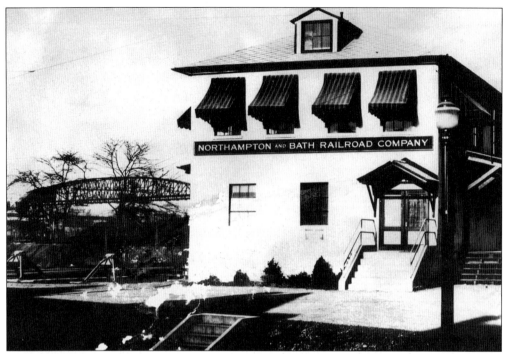

The Northampton and Bath Railroad Company headquarters is shown in this 1955 eastward view from Main Street. It is a rare photograph, as it features the coal-unloading crane bridge to the left. This is the site of today's Newhard drugstore. (Courtesy of John Pavis.)

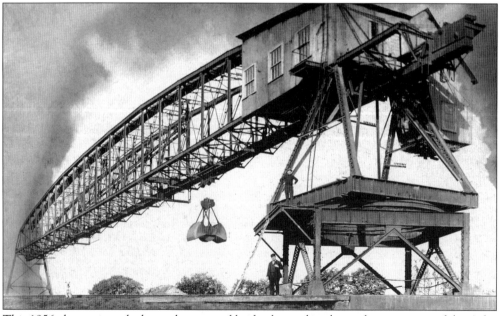

This 1956 closeup reveals the coal crane and bridge located in the coal-storage area of the Atlas plant. Used to unload coal from trains, this bridge swung a full 360 degrees. Frank Thomas is the crane operator here. Located on the site of the Northampton Fire Company building on today's Lerchenmiller Drive, the crane was taken down in 1958.

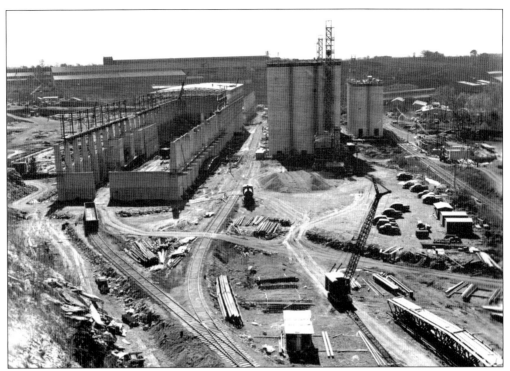
The last Atlas plant, No. 5, is under construction in this southward view of October 16, 1941. Today, the plant serves as the site of the Northampton Generating Company. (Courtesy of Edward Pany.)

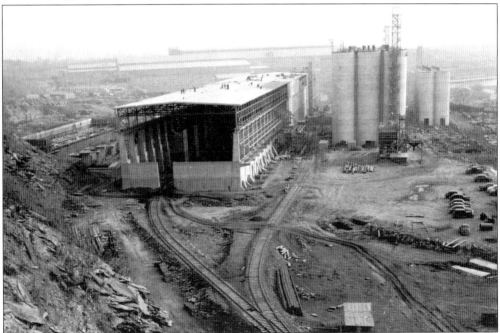
Construction of the rock-storage building at Atlas Plant No. 5 had begun by November 19, 1941, by its then owner, the U.S. Steel Company. (Courtesy of Edward Pany.)

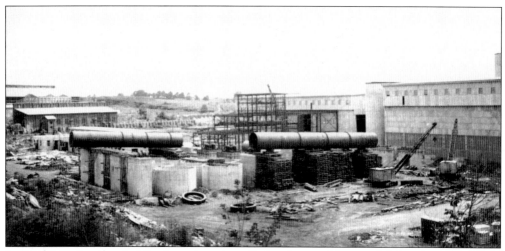
In this 1942 photograph, kilns have been installed at the new Universal Atlas plant. (Courtesy of Edward Pany.)

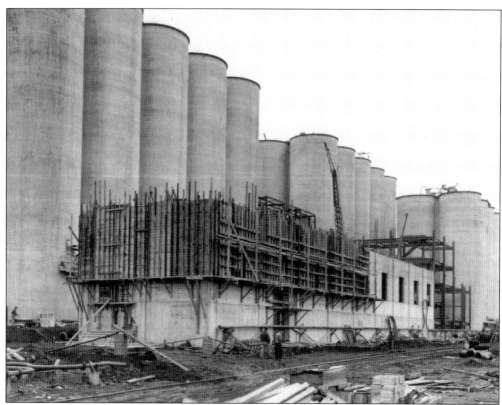
The Universal Atlas pack house was built by Turner and McDonald Construction in 1942. (Courtesy of Edward Pany.)

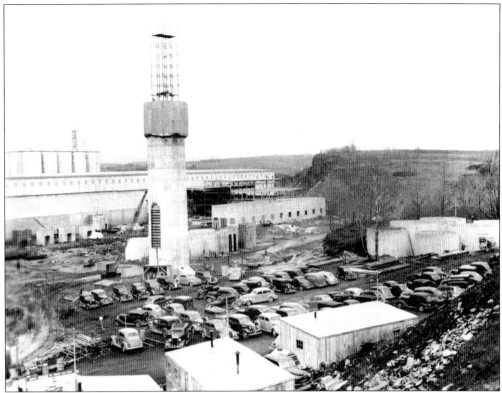

This January 20, 1942, photograph of Plant No. 5 shows the stack construction. A Northampton landmark until its demolition in 1994, the stack was 250 feet high. (Courtesy of Edward Pany.)

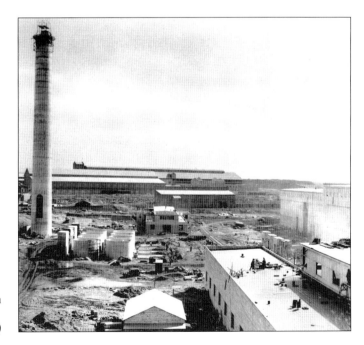

Taken on February 23, 1942, this photograph offers an overall view of the construction of Plant No. 5. The plant closed on August 24, 1982, ending a proud and distinguished era in Northampton history. (Courtesy of Edward Pany.)

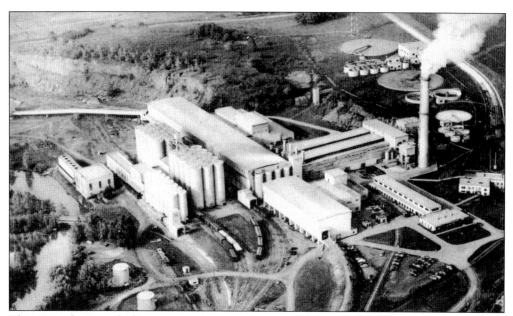
This 1943 photograph shows a complete aerial view of Universal Atlas Plant No. 5. (Courtesy of Edward Pany.)

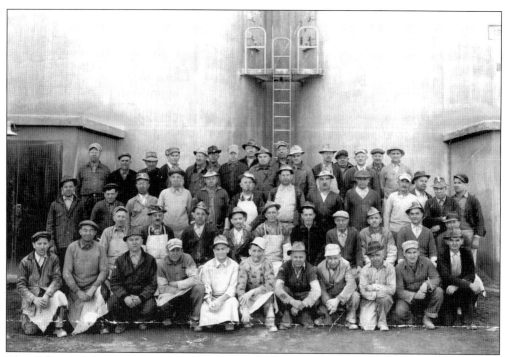
The Atlas pack house crew poses for a 1948 photograph. The silos still stand. (Courtesy of Edward Pany.)

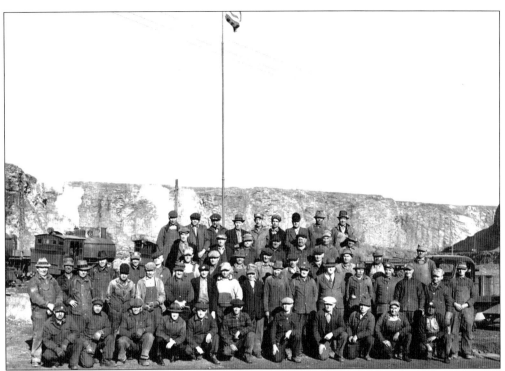

As the Atlas Quarry crew poses c. 1946, the last steam locomotive on an Atlas site is visible to the left. (Courtesy of Edward Pany.)

Looking west, this 1950 view shows Universal Atlas Plant No. 5 and the company office. (Courtesy of Ralph Hoffman.)

Universal Atlas Plant No. 5 is shown in this 1943 eastward view. The plant featured a new wet process in its cement production. (Courtesy of Edward Pany.)

This southward view, taken in May 1944, depicts Universal Atlas Plant No. 5.

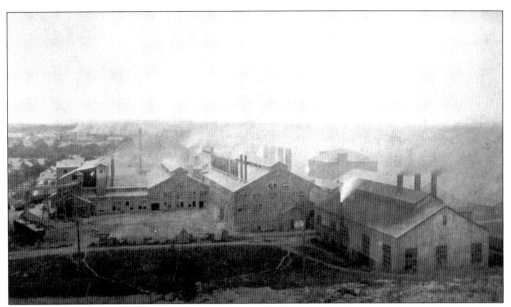

The Bonneville Cement Company, formerly the Allen Cement Company, is seen here in 1899. It later became both the Lawrence Portland and Dragon Cement Companies.

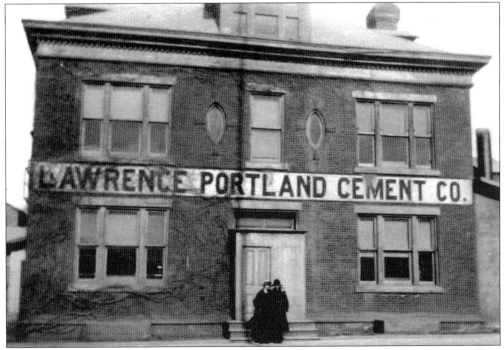

This 1920 photograph shows the Lawrence Portland headquarters along 21st Street, where Dragon cement was produced. It was last owned by the Martin Marietta Corporation, eventually closing in 1983. (Courtesy of Edward Pany.)

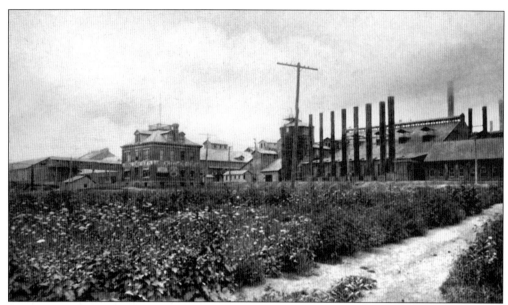
The Lawrence Portland Cement Company office and kiln building are pictured in 1926. (Courtesy of Ralph Hoffman.)

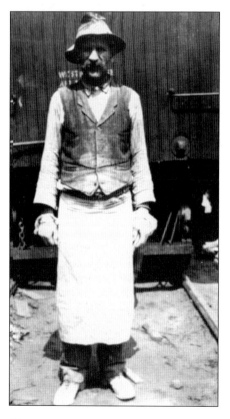
Among other duties at the Lawrence Portland Cement Company, this cement packer was responsible for loading cement into wooden barrels and cloth bags. (Courtesy of Edward Pany.)

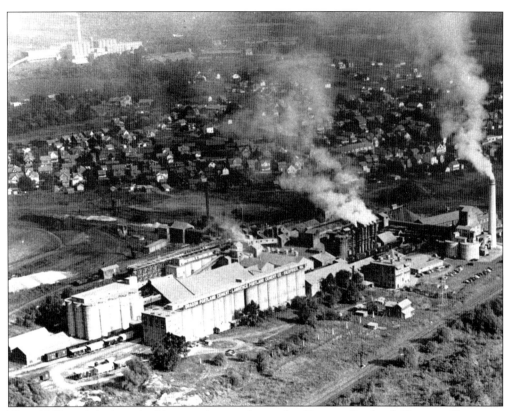
This 1949 aerial view, looking southeast, shows the Dragon Portland Cement Company. Universal Atlas Plant No. 5 is visible in the upper left corner. (Courtesy of Edward Pany.)

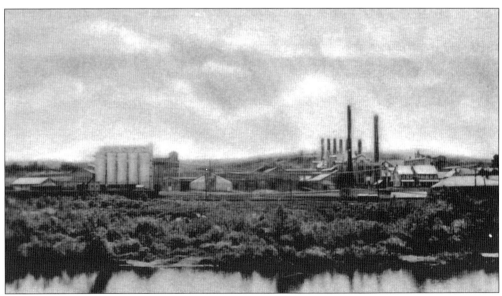
This 1934 view looks east to the Lawrence Portland Cement Company, located along the banks of the Lehigh River. (Courtesy of Ralph Hoffman.)

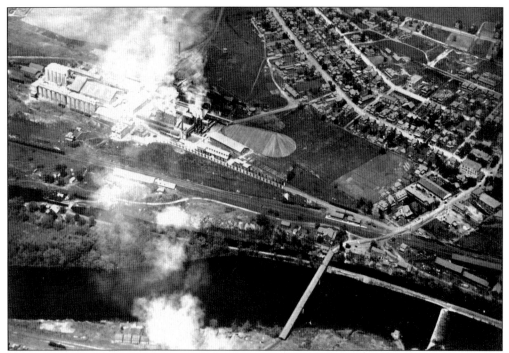

Looking northeast, this c. 1920s photograph provides a bird's-eye view of the Lawrence Portland Cement Company. Of special note are the covered Siegfried Bridge and the configuration of 21st Street in the lower right quadrant. (Courtesy of Raymond E. Holland.)

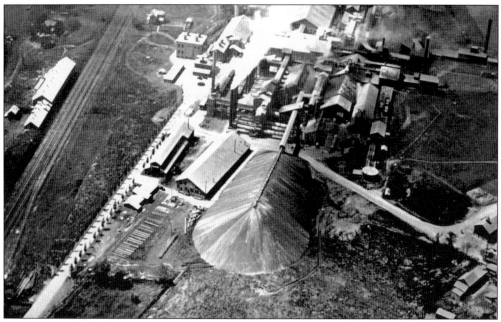

The Lawrence Portland Cement Company, producer of Dragon cement, is shown in this late-1920s northward view. In the lower left corner, the rail siding breaks off the main tracks serving the Siegfried station. (Courtesy of Raymond E. Holland.)

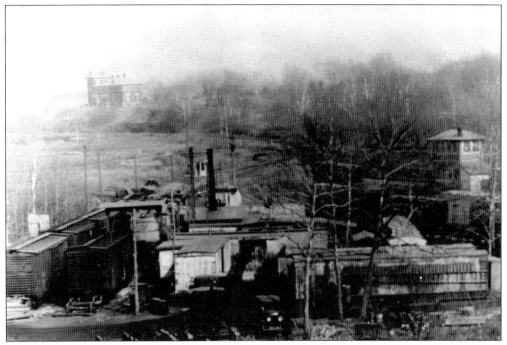

The original diesel, electric locomotive, and car-repair facility for the Northampton and Bath Railroad is depicted in this c. 1940 photograph. Note the Atlas Cement Company headquarters in the upper left corner, located at this site in order to oversee all of the plants. (Courtesy of Edward Pany.)

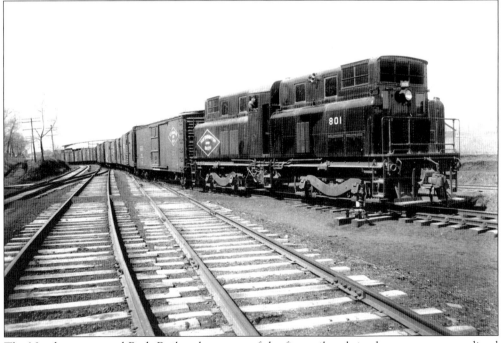

The Northampton and Bath Railroad was one of the first railroads in the country to use diesel engines. A diesel train is seen here in 1942. (Courtesy of Edward Pany.)

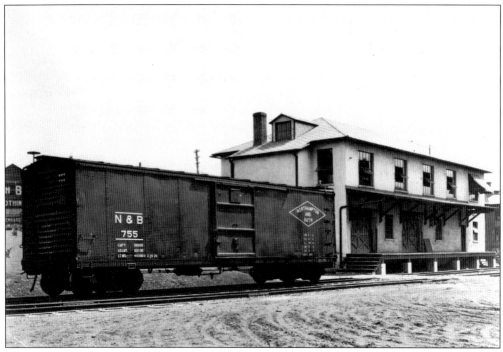

This c. 1955 photograph shows the Northampton and Bath Railroad headquarters. The building, which also served as a depot, is currently the site of the Newhard drugstore. (Courtesy of Edward Pany.)

The Northampton and Bath Railroad headquarters is shown in this southward view of Main Street from Laubach Avenue. The station was razed in 1974.

Three
THE TOWN KNOWN AS NORTHAMPTON

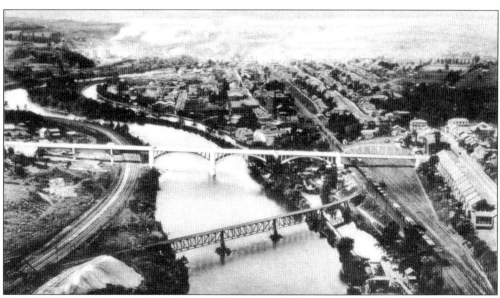

This 1931 bird's-eye view of Northampton looks north. As one can see, the Lehigh Canal runs parallel to the Lehigh River with the lock and lockkeeper's house.

The Dry Run Trestle and Trolley ran along Main Street near Fourth, as seen in this c. 1948 photograph. The trolley was operated by the Lehigh Valley Traction Company, started by Gen. Harry Trexler. This view looks north from the present Hampton Lanes parking lot. (Courtesy of Frank Keller Jr.)

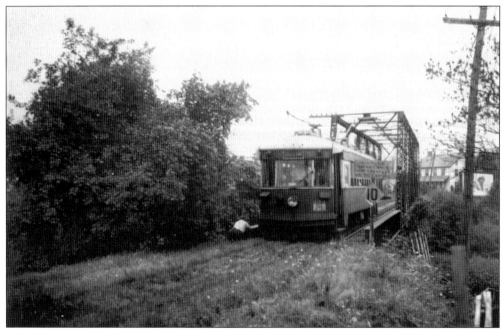

Lehigh Valley transit car No. 434 crosses the Dry Run Trestle in 1952. The trolley ran every half-hour between Northampton and Allentown.

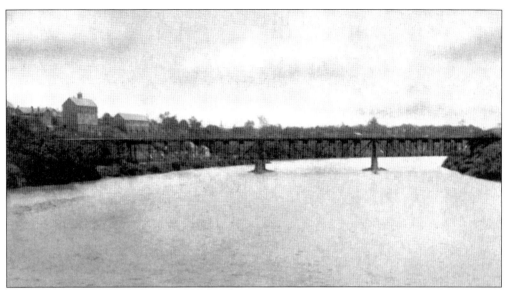

The train trestle was located over the Lehigh River, just south of the Northampton-Coplay Bridge, and was washed away in the flood of 1942. (Courtesy of Ralph Hoffman.)

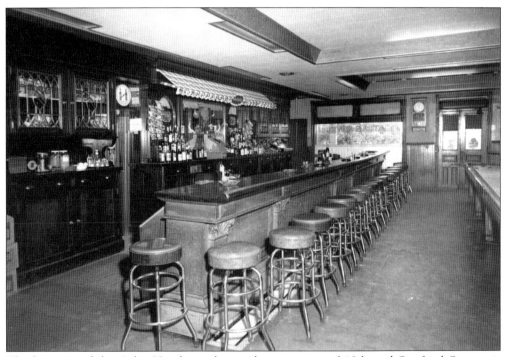

The barroom of the Atlas Hotel, on the southwest corner of 10th and Siegfried Streets, is shown in this c. 1950 photograph. Acquired in 1947 by Alois and Theresa Yandrisevits, the hotel was at one time a boardinghouse and local watering hole for Atlas Cement plant workers. (Courtesy of Frank Yandrisevits.)

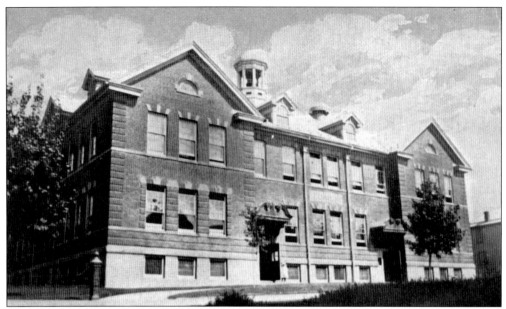

The Franklin School, seen here in 1947, was located at the southeast corner of Ninth Street and Lincoln Avenue. The school was built at a cost of $32,429. (Courtesy of Ralph Hoffman.)

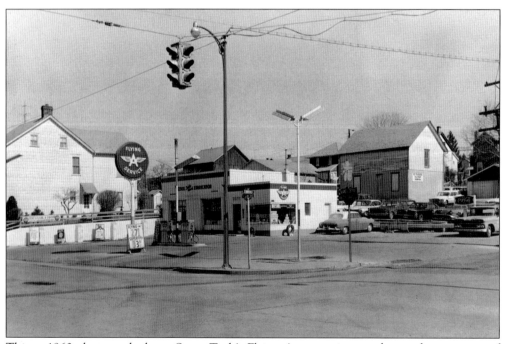

This c. 1960 photograph shows Steve Toth's Flying A gas station, at the northeast corner of Main and Ninth Streets. Originally owned by John Radokovits, it was known as Docky's Tydol station. (Courtesy of Stephen Toth.)

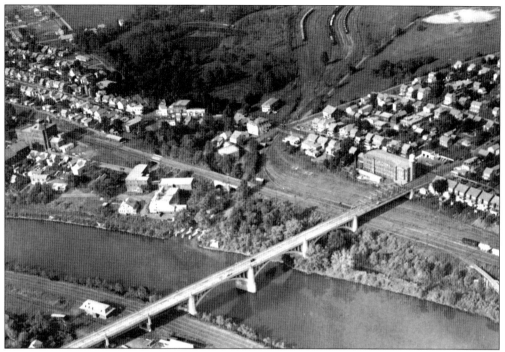

In this 1951 bird's-eye view of Northampton, the Northampton and Bath Railroad headquarters is the white building in the center.

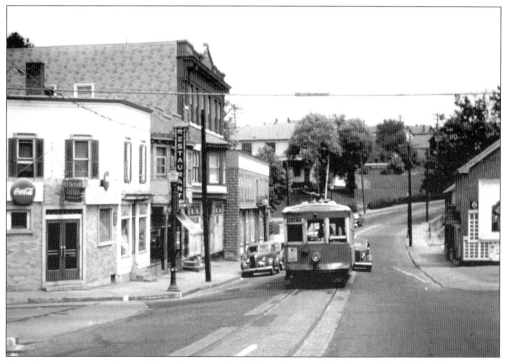

A trolley car run south on Main Street at the Hokendauqua Creek in 1953. Polzer's Restaurant can be seen on the left.

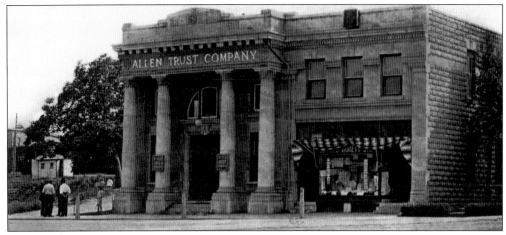

The Allen Trust Company, shown c. 1929, was located at the southwest corner of Main Street and Laubach Avenue. After the company closed in 1933, the building was extensively used during World War II as home to many wartime boards, most notably the draft board, the rationing board, and the Office of Price Administration. The business to the right of the trust company is Ginzberg's, which became the Joseph Roth store in 1947. (Courtesy of Ralph Hoffman.)

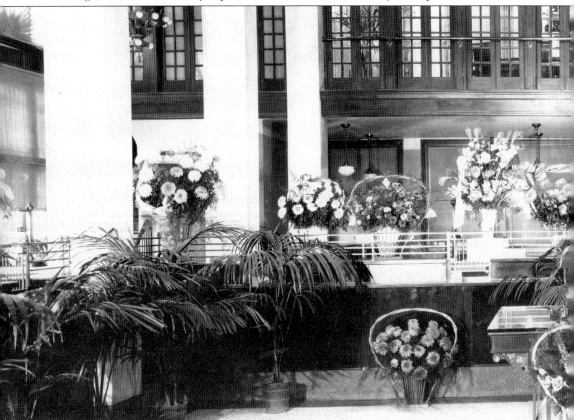

This panoramic view of the Allen Trust Company shows the palatial remodeled interior just prior to the grand opening on October 12, 1929. The Allen Trust Company had the unfortunate timing to open a mere 17 days before the stock market crash and subsequent

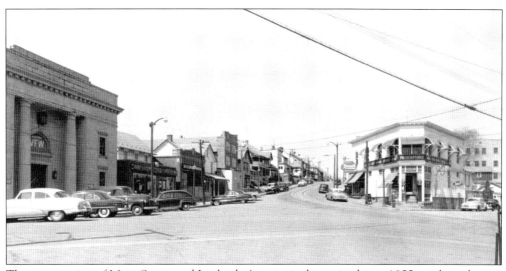

The intersection of Main Street and Laubach Avenue is shown in this c. 1955 northward view.

depression. Although the company had enough assets in mortgages, there was not enough liquidity to stay the course. The trust company was taken over by Cement National Bank in 1932. (Courtesy of Robert Mentzell.)

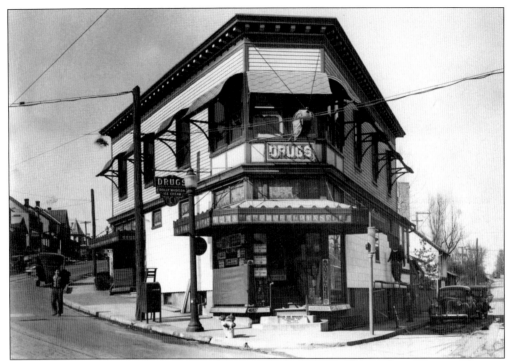

Meixsell's, seen here c. 1935, was located at the north corner of Main Street and Laubach Avenue. The drugstore was owned by Dr. Charles Meixsell, who was also a practicing physician at the time. In 1943, it was purchased by Aaron and Erma Newhard. (Courtesy of John Pavis.)

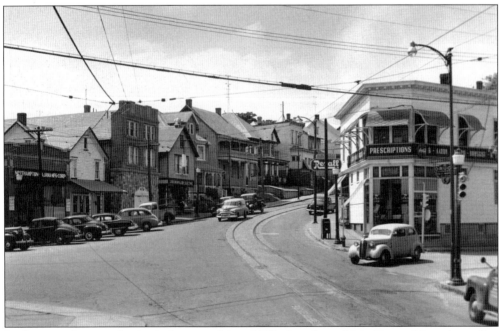

Looking northwest at Laubach Avenue, this c. 1955 view shows Main Street. Note the trolley tracks (center) and the Northampton Pajama Company (left).

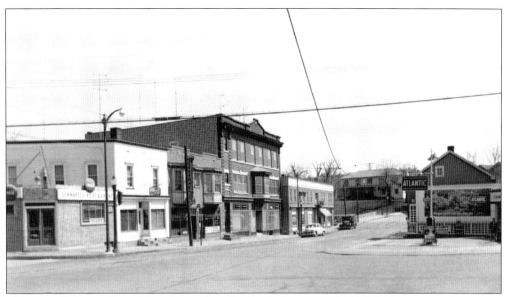

This view looks south on Main Street from Laubach Avenue c. 1953. The businesses shown are, from left to right, Schwartz's Restaurant, the restaurant of Slim Eberhardt, the A&P (later Northampton Dress), John Sylvester Insurance, and Greb's Barber Shop. On the hill in the background is the Northampton and Bath Railroad. On the right is Lentz's Atlantic gas station.

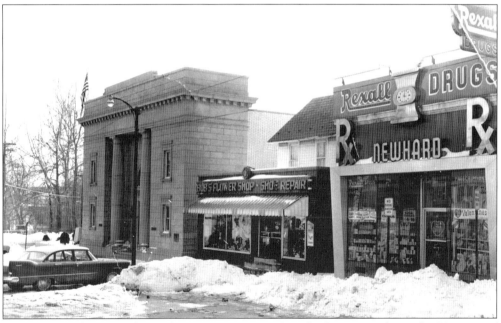

This 1961 southwestward view from Main Street and Laubach Avenue shows the Veterans of Foreign Wars building (formerly the Allen Trust Company), Bob's Flower Shop, and the Newhard drugstore. Bob's Flower Shop was named for former owner Robert Transue, who started the business in 1940 at 1057 Main Street. After moving to this location in 1943, the business was subsequently sold to Barbara and Dale Miller in 1980, and they continue to operate the business to this day. (Courtesy of Barbara Miller.)

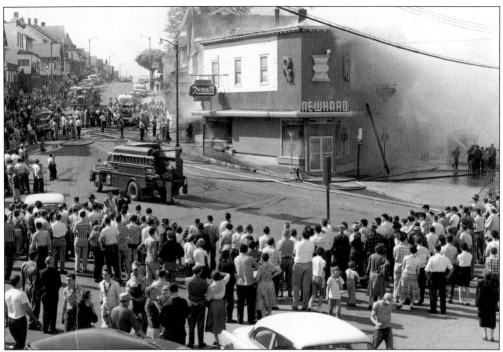

This is a glimpse of the fire that completely destroyed the Newhard drugstore, at 1205 Main Street, on May 19, 1956. The store subsequently moved across the street to 1216 Main, formerly occupied by the Northampton Pajama Company. (Courtesy of David Rank Jr.)

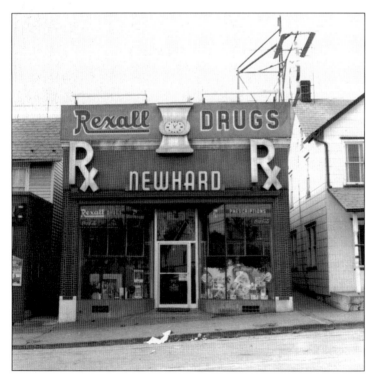

The Newhard Rexall drugstore, shown in 1959, was located at 1216 Main Street. When Aaron and Erma Newhard sold the store, it became the partnership of Peter Stahl and John Pavis, who continued to run it after relocating to the former Northampton and Bath Railroad property in 1975. (Courtesy of Fella Studios.)

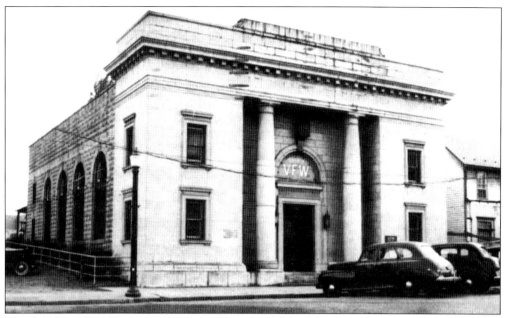

The Post No. 4714 Veterans of Foreign Wars (VFW) building, seen here c. 1950, is located at the southwest corner of Main Street and Laubach Avenue. The VFW was founded by returning veterans of World War II. (Courtesy of Ralph Hoffman.)

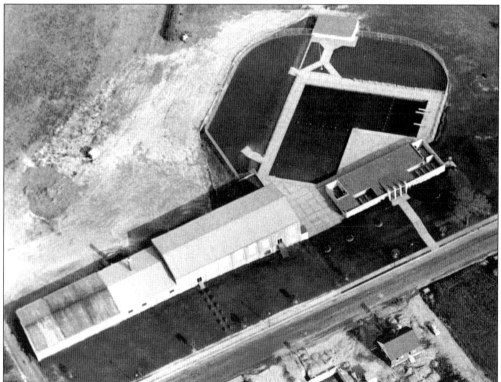

This 1952 aerial view shows the newly completed Northampton Municipal Swimming Pool and the adjacent Northampton Memorial Community Center. (Courtesy of Gene Zarayko.)

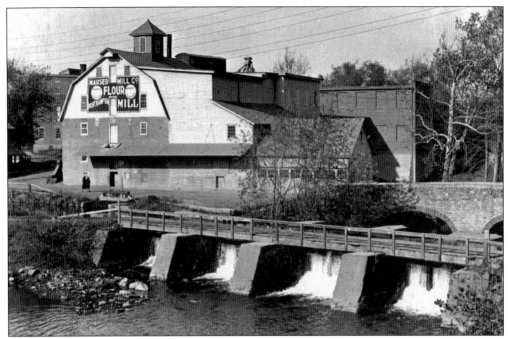

The Mauser Mill, pictured here c. 1935, was located at the mouth of the Hokendauqua Creek at the Lehigh River. Last owned by R. A. Smith, the mill burned down in 1952. (Courtesy of James Benetzky.)

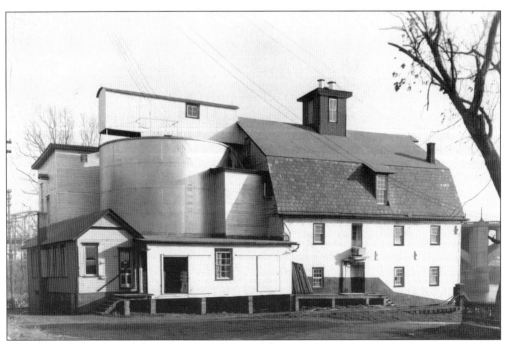

This c. 1950 southward view shows the Mauser Mill from Laubach Avenue. The mill, originally started in 1796 by Henrich Biel, was purchased in 1822 by the Laubach family. The Northampton-Coplay Bridge is visible in the background to the right. (Courtesy of Edward Pany.)

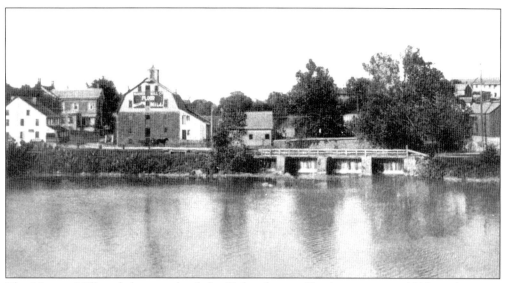

The Mauser Mill and the mouth of the Hokendauqua Creek are seen c. 1915 in this view looking east from the Lehigh River. The second house on the left, the Adam Laubach House, is the only structure currently standing.

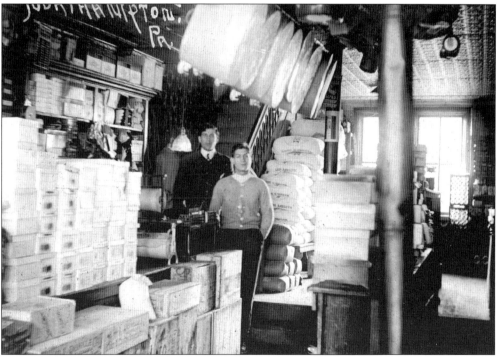

The Frank Segal store, seen here in the 1920s, is thought to have been located in the Newport area.

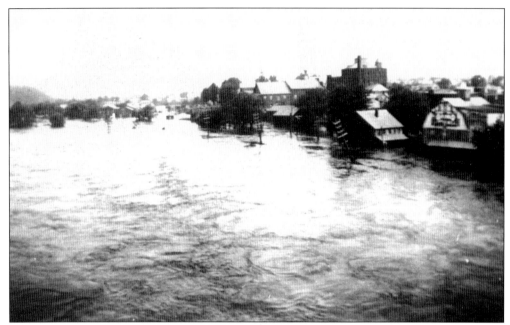
Looking north from the Northampton-Coplay Bridge, this view shows the Newport area after the flood of 1942. (Courtesy of Frank Keller Jr.)

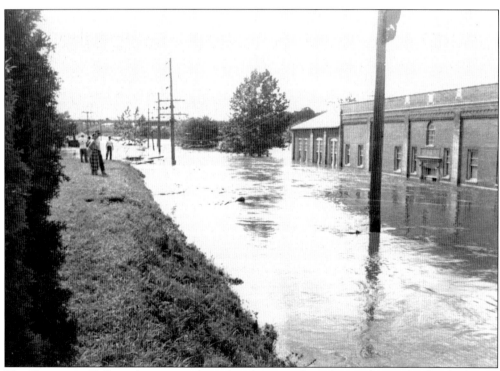
The Hungarian Hall can be seen to the right of this southward view during the flood of 1955. (Courtesy of David Rank Jr.)

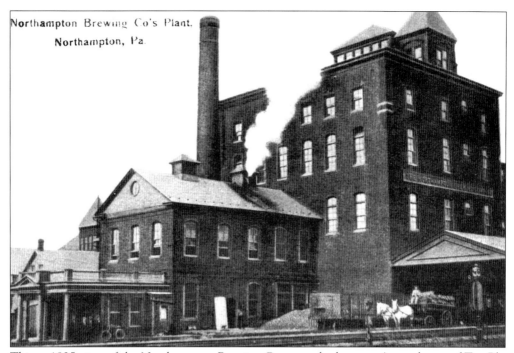

This c. 1925 view of the Northampton Brewing Company looks west. As producers of Tru-Blu beer and ale, the business advertised the popular beer, ale, and porter as "the beer that makes and keeps friends." The plant was located in the 1400 block of Newport Avenue. Note the horse-drawn beer wagon to the right.

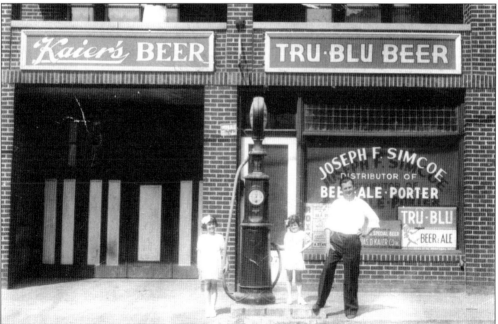

Joseph F. Simcoe Beverage was located at 1307 Newport Avenue. Pictured in 1937 are Joseph, who ran the business at this location for more than 50 years, and his daughters Ethelmae (left) and Eleanore. Note the Tru-Blu and Roxy Theatre signs. (Courtesy of the Carol Simcoe family.)

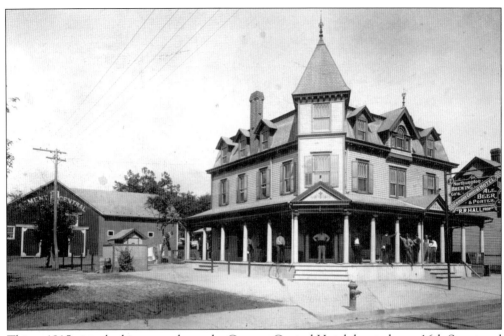

This c. 1915 view, looking east, shows the Cement Central Hotel, located near 16th Street and Newport Avenue. Note the Tru-Blu sign to the right. (Courtesy of Raymond E. Holland.)

Werbicky's Tavern, at the northeast corner of 15th Street and Newport Avenue, was photographed c. 1925.

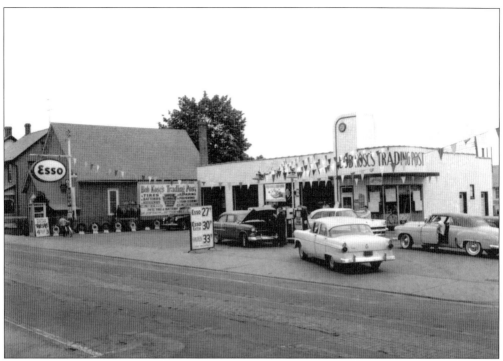

Bob Kosc's Trading Post and Esso gas station are shown here in 1959 at the southwest corner of 17th and Main Streets. The gas station had been owned by the Radio brothers until 1953. The Knights of Columbus Home is to the left. Those are actual gas prices, folks. (Courtesy of Fella Studios.)

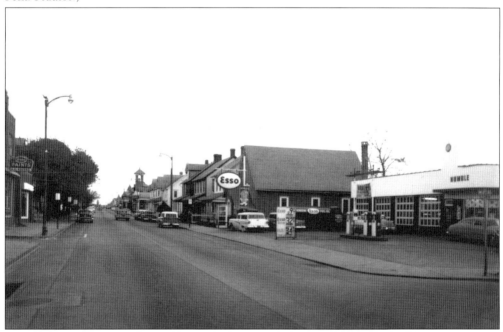

Main Street is shown in this 1958 view looking south from 17th Street. The Kozero paint store is to the left, and Bob Kosc's Esso gas station appears to the right. (Courtesy of Fella Studios.)

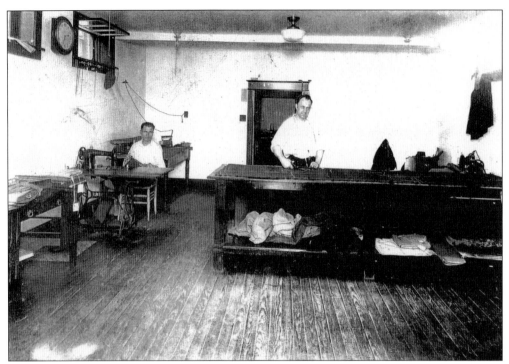
The Lahovski tailoring shop was located at 1661 Main Street when this 1925 photograph was taken. This was their first location. Pictured here are owner Stephen Lahovski (standing) and Tony Mazur.

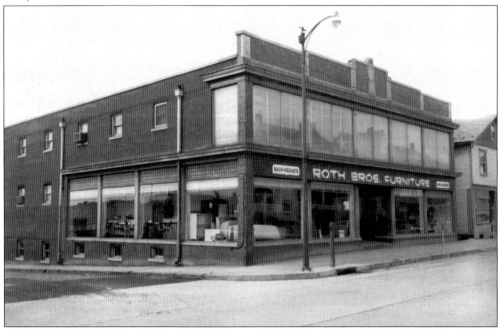
Photographed c. 1960, Roth Brothers Furniture was located at the northwest corner of 17th and Main Streets. Originally at the corner of Newport and Laubach Avenues, it was one of the oldest furniture stores in the borough. (Courtesy of Fella Studios.)

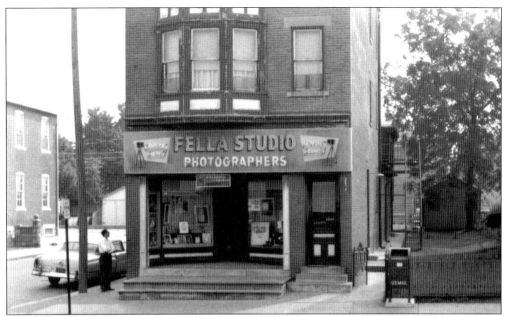

Fella Studios is seen here in 1960. Located at the southeast corner of 15th and Main Streets, the business was started in 1945 by Bernard Fella, who was joined shortly thereafter by brothers Rudolph, Edward, and Martin. In 1977, Martin Fella Jr. took over operations. (Courtesy of Fella Studios.)

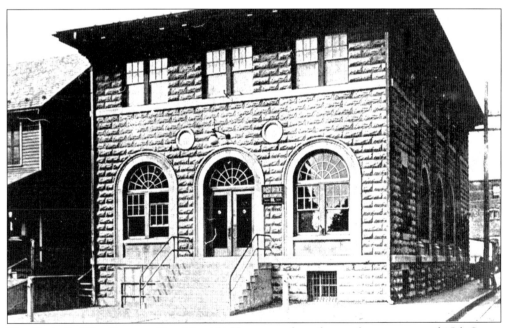

The Catholic War Veterans Post No. 454 Home stands at the southwest corner of 15th Street and Washington Avenue. Organized in 1945, this group of veterans joined to promote a greater love, honor, and service to God, country, and home. In 1914, this building housed Northampton's first post office (before it moved to the Mount Vernon Inn). It was also once used as a Jewish synagogue.

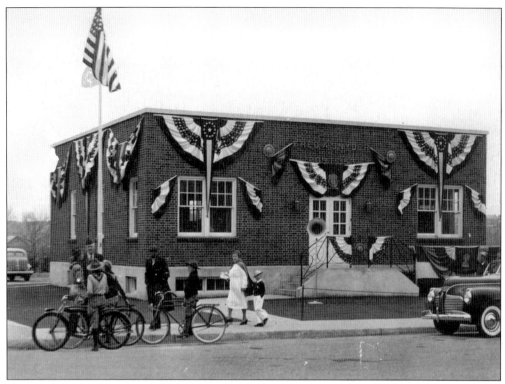

The Fred Snyder Post No. 353 American Legion building, shown in 1942, was located at the southeast corner of 15th Street and Dewey Avenue. It was built by Monroe Miller and Dr. Charles Half in 1940. (Courtesy of Jack DeLabar.)

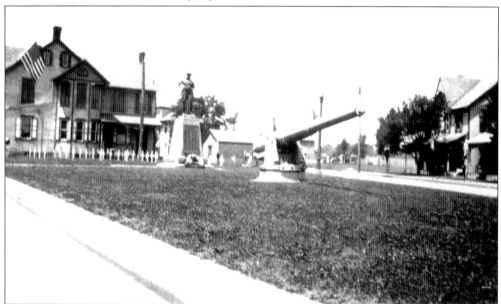

This 1930s view displays the Northampton Memorial Plot, located on the north side of 14th Street at Washington Avenue. The cannon in the foreground was melted down and used in the World War II effort. (Courtesy of Ralph Hoffman.)

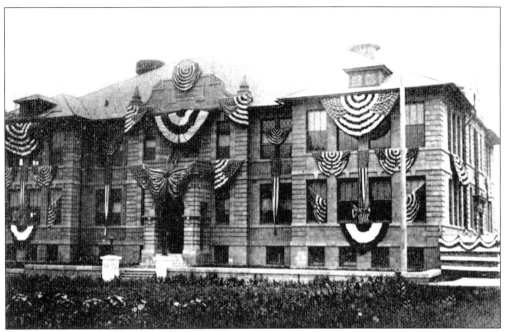

The dedication of the new Northampton High School, at the northwest corner of 18th Street and Lincoln Avenue, took place in 1910. (Courtesy of Ralph Hoffman.)

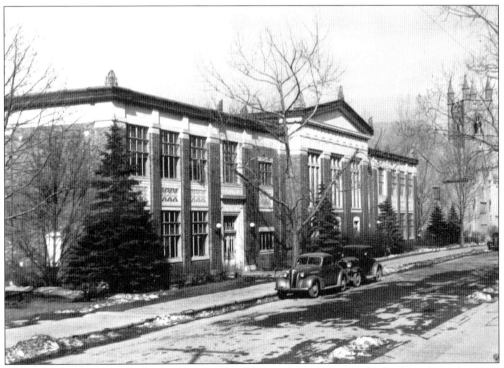

This c. 1929 photograph shows the completed Northampton Junior High School, in the 1800 block of Lincoln Avenue. The school was built in 1927 at a cost of $275,000.

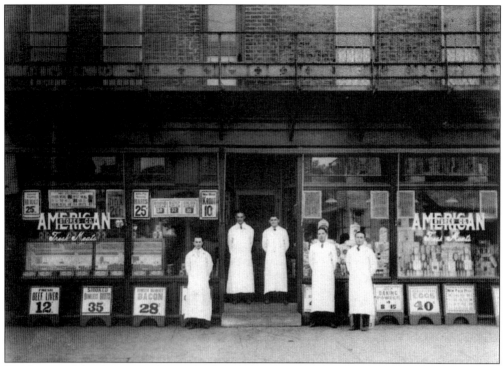

Employees of the American Stores Company pose for a photograph in 1918. Located at 1756 Main Street, this grocery store chain later became the Acme Market. One can still see the balcony on the building today. (Courtesy of Art Brown.)

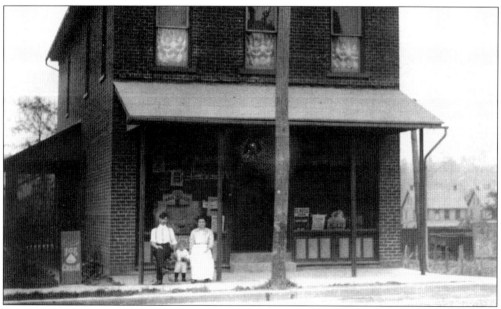

This is a 1916 view of the original store at 1756 Main Street. Pictured are owners Stefan and Erma Luisser. It served as a sweet shop, selling candy, soda, ice cream, and cigars. (Courtesy of Art Brown.)

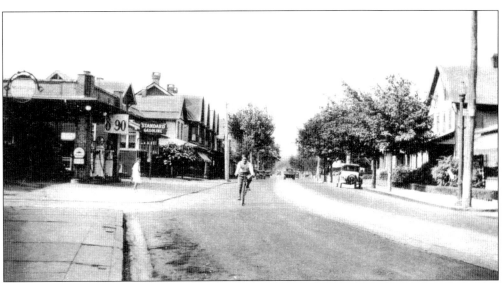
Looking north from the 1700 block, this view shows Main Street c. the 1950s. The Quality Service Station is to the left. (Courtesy of Ralph Hoffman.)

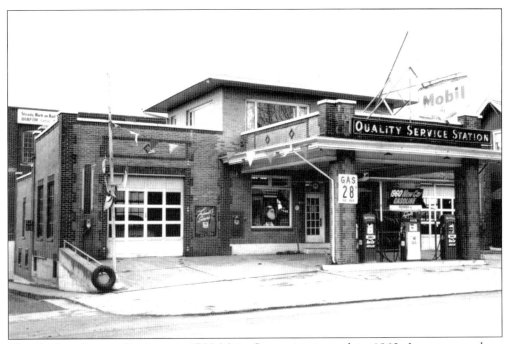
The Quality Service Station, at 1766 Main Street, is pictured in 1960. It was opened on December 13, 1929, by George H. Schisler. (Courtesy of Fella Studios.)

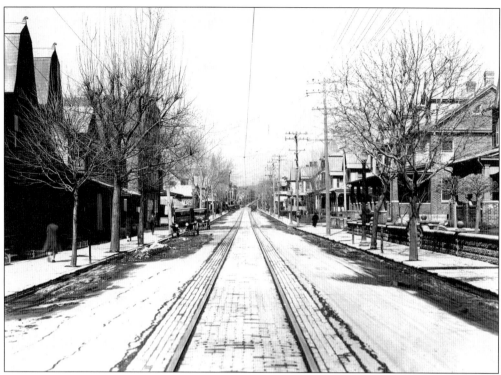

Main Street is seen c. 1908 in this view looking north from the 1700 block. Note the original Lerner's sign and location on the left side. (Courtesy of the *Morning Call*.)

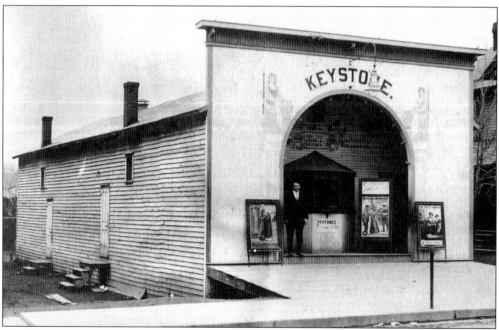

Harry Hartman's original movie house, the Keystone Theatre, was located at the northwest corner of 18th and Main Streets, as seen in this 1920 photograph. (Courtesy of Richard Wolfe.)

This is a 1950 view of Cross County Clothes, on the north side of West 21st Street. Note the house to the far left, which was home to Martnick's Bar and the Schneider family. (Courtesy of Fella Studios.)

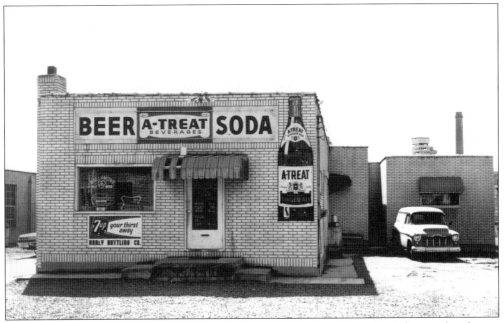

DalPezzo's Steak Shop, on Center Street near 21st Street, is seen in 1958. A favorite lunch spot for the nearby factories, this building became the home of R&S Printers in 1964. (Courtesy of Fella Studios.)

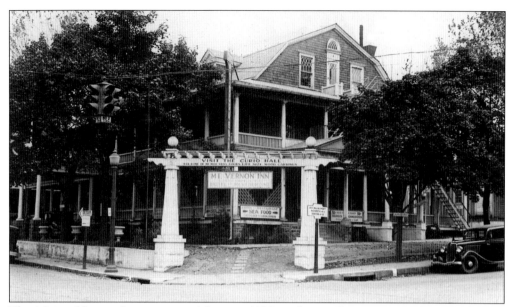

The Mount Vernon Inn is pictured here c. 1939 at the northeast corner of 21st and Main Streets. The wooden archway was a recent addition. Note the overgrown trees and other changes from the photographs on page 27. (Courtesy of the Morning Call.)

The Berg Mansion was the home to John and Anna Berg, pictured in the foreground c. 1938. The house was located on the south side of West 21st Street, next to the Allen House. (Courtesy of Art Brown.)

The Hess Garage, located at 24 West 21st Street, is seen in this c. 1935 view. Owned by Mervin Hess at that time, it was previously known as Michael's Garage. Note the Berg Mansion to the left. (Courtesy of Art Brown, in memory of Mervin Hess.)

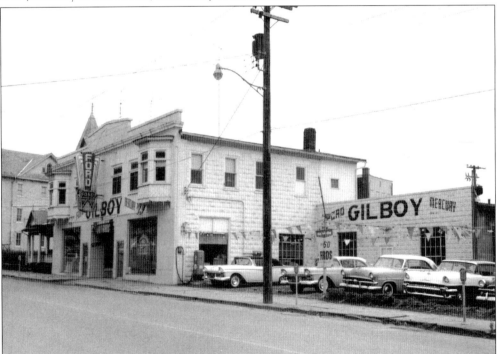

This 1957 view of Gilboy Ford shows its location at 24 West 21st Street, the former site of the Hess Garage. The building was later used by Cross County Clothes. (Courtesy of Fella Studios.)

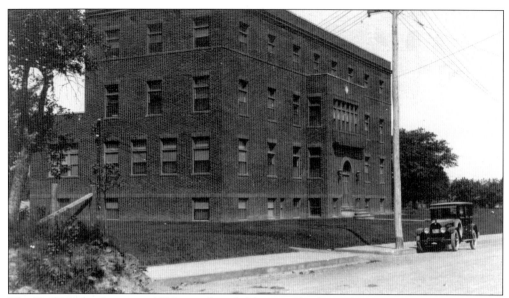

The Half Hospital, seen c. 1922, was founded by Dr. Charles Half in 1918 and moved to this location at 2006 Laubach Avenue in 1922. This building accommodated up to 40 patients. It currently houses the administrative offices of the Northampton Area School District.

This eastward view highlights the north side of 21st Street at Lincoln Avenue c. the 1920s. These houses were built by H. A. Miller and Franklin Silfies, owner of Northampton Lumber. The far right house was the former office of Dr. Donald Half, son of Dr. Charles Half. (Courtesy of Ralph Hoffman.)

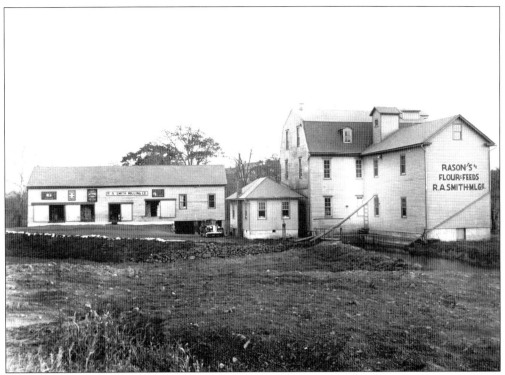

This c. 1945 photograph of the R. A. Smith Milling Company shows its location at 600 East 21st Street at the Hokendauqua Creek. Started in 1889 by Richard A. Smith, the business was passed to his son Stanley C. Smith in 1924. (Courtesy of Edward Pany.)

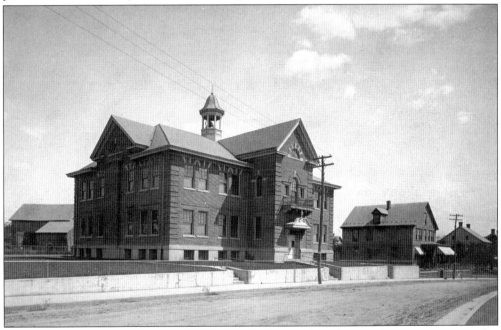

The Washington School, at the southeast corner of 24th and Main Streets, is seen in this c. 1910 image. (Courtesy of Ralph Hoffman.)

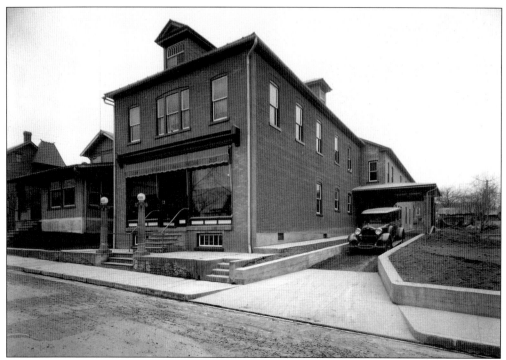

The Schisler Funeral Home, photographed c. 1929, was located at the northeast corner of 21st Street and Washington Avenue. Founded by Albert F. Schisler in 1929, the business was then operated by his son Harold M. Schisler, and subsequently by Arthur R., Aaron A., and Harold C. throughout the years. (Courtesy of the Morning Call.)

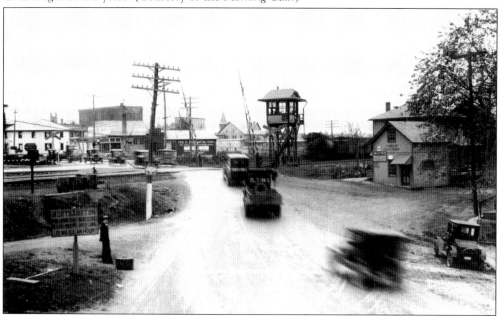

The railroad crossing at 21st Street is shown here c. 1928. The sign to the left describes Northampton as "the town that wants you," a phrase that later became the title of a comprehensive area history written by Ray F. Wahl in 1941.

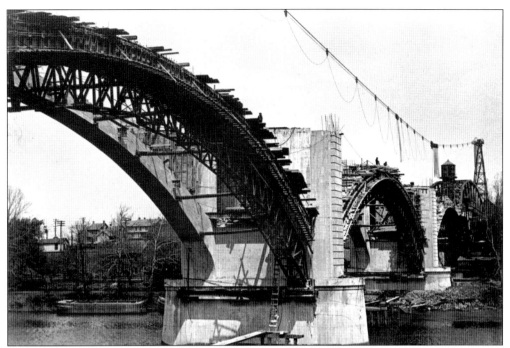

Construction of the new Northampton-Coplay Bridge was under way at the time of this photograph in 1929–1930. This view was taken from the Coplay side, with part of the trestle already complete on the right side. (Courtesy of James Benetzky.)

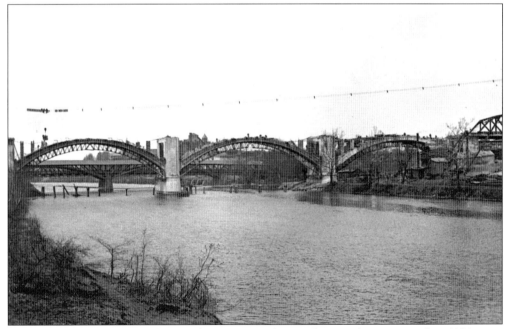

The completed arches of the Northampton-Coplay Bridge can be seen in this 1930 view looking north from Coplay. The old covered bridge is visible under the arches in the distance. The bridge was dedicated in August 1930. Charles Fox, the burgess of Northampton, led the dedication proceedings. (Courtesy of James Benetzky.)

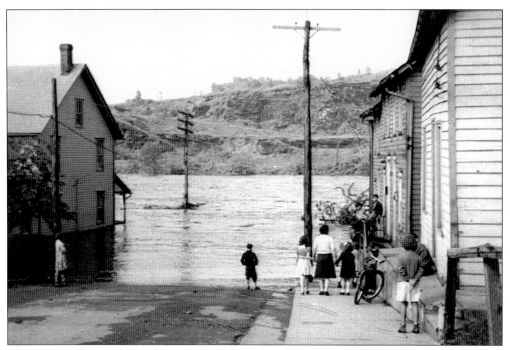

This westward view shows the May 1942 flood from lower 17th and Canal Streets. (Courtesy of Frank Keller Jr.)

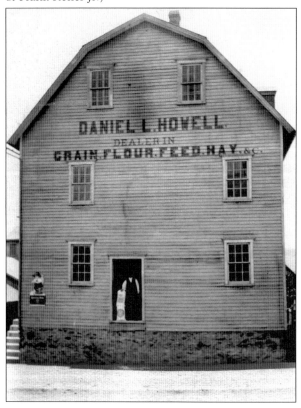

The mill of Daniel Howell, pictured c. 1905, was located on the west side of Washington Avenue just north of 21st Street.

Four
UPTOWN

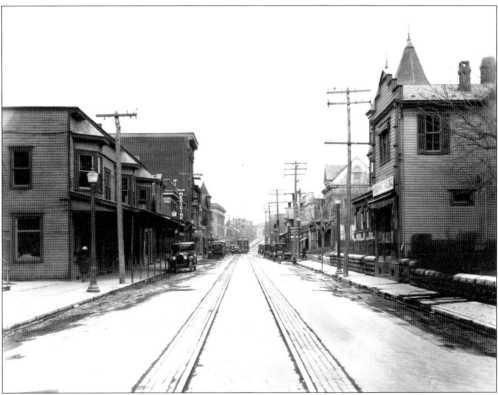

This 1903 view of Main Street looks north from 19th Street. Erdosy Tailors is the first building on the right side, and on the left, one can spy the original M&N Medicine sign, where the store was located. Long known as "uptown," the Main Street area between 18th and 21st Streets has been known as the de facto business district of Northampton over the years. (Courtesy of the *Morning Call*.)

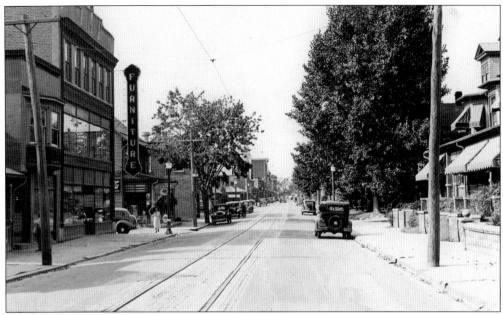

Main Street is shown in this *c.* 1909 northward view from just below 18th Street. Borger's Furniture is visible to the left, and one can catch a glimpse of the Georgian Restaurant, formerly the Gross Shoe Store, to the right of Borger's. (Courtesy of the *Morning Call*.)

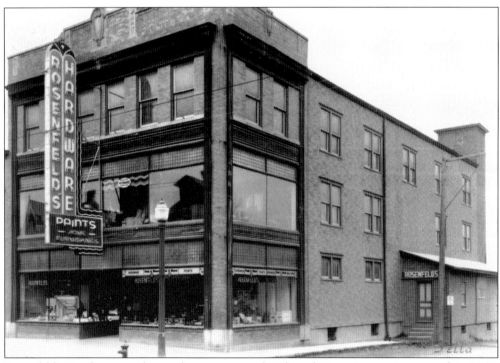

Rosenfeld's Hardware, at the southwest corner of 18th and Main Streets, is pictured in 1958. Formerly the site of Borger's Furniture, this building subsequently housed Tama Manufacturing. (Courtesy Fella Studios.)

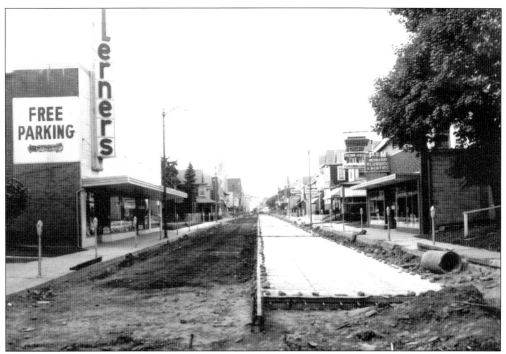

In this northward view from 18th Street, Main Street is under construction in September 1959 after the removal of the trolley train tracks. (Courtesy of Fella Studios.)

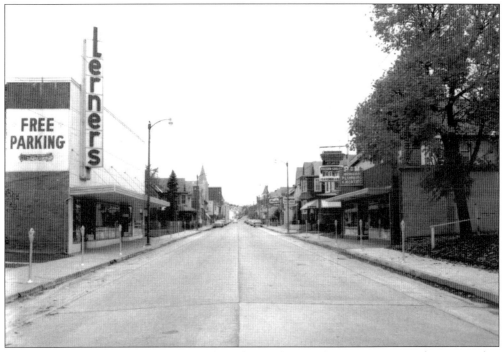

The "new" Main Street, again in a northward view from 18th Street, is pictured in November 1959 after the re-paving was completed. (Courtesy of Fella Studios.)

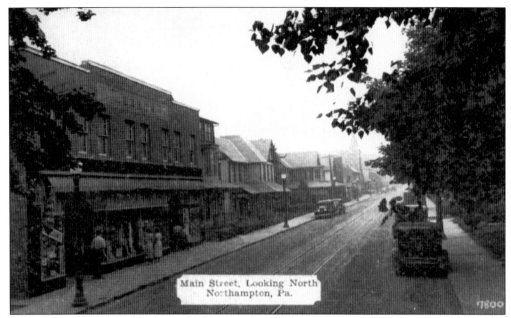

This 1931 photograph shows Main Street's west side. Prominent is the first Lerner's (left), seen before fire destroyed it in 1933. The department store was originally opened in the old Keystone Theatre, featured on page 23. (Courtesy of Ralph Hoffman.)

P&M Plumbing (Paukovits and Martnick) was located at 1805 Main Street in 1959. Originally opened in the early 1950s, the business actively sold plumbing and heating supplies into the late 1960s. The store subsequently became a Penn-Jersey automotive store. (Courtesy of Fella Studios.)

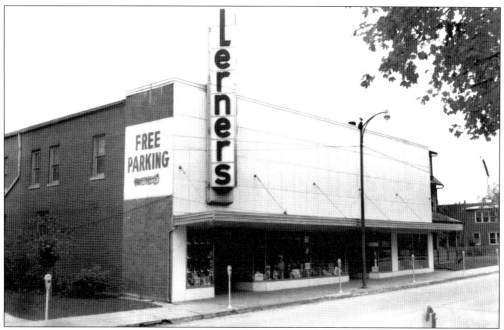

Lerner's, seen at 1804 Main Street in 1959, was opened in 1934 after a fire destroyed the previous building. After the department store closed in the late 1960s, Drug City occupied the building until a fire destroyed it in August 1971. (Courtesy of Fella Studios.)

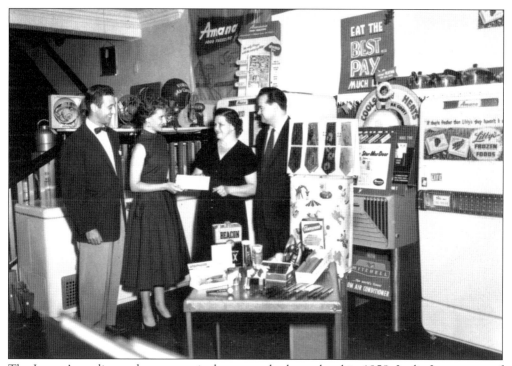

The Lerner's appliance department is shown on the lower level in 1958. Leslie Lerner, son of the owner, appears on the left. (Courtesy of Fella Studios.)

This 1959 view shows the Kruper Brothers appliance store, located at 1841 Main Street. The business was started in 1936. Brothers Mike, Frank, John, and Steve made this their Northampton location in the early 1940s, after moving from Coplay. (Courtesy of Fella Studios.)

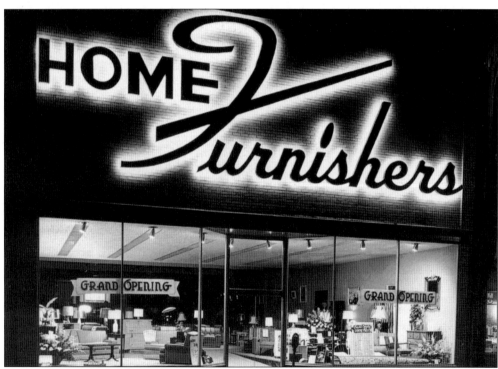

Northampton Home Furnishers celebrates its grand reopening in 1956. At 1852–1854 Main Street, the store was owned by founder Cecil Salman and his son Gerald at that time. Fire damaged the building in 1955, and the business stayed closed until May 1956. Upon reopening, the newly remodeled store featured air-conditioning, a new concept for that time period. (Courtesy Fella Studios.)

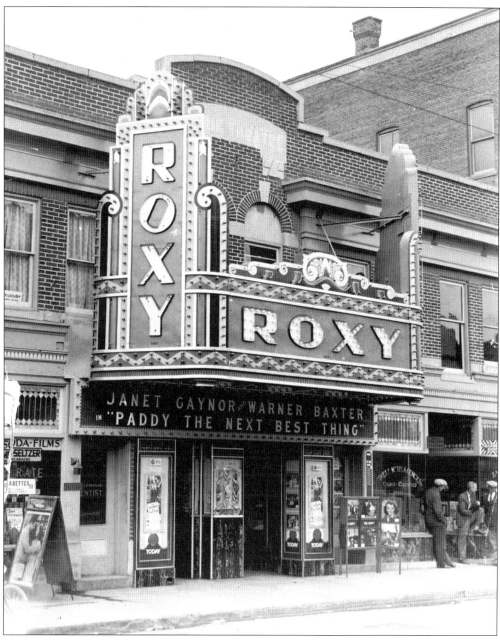
The majestic Roxy Theatre was photographed on Friday, September 21, 1933, a few weeks after the August 31 grand opening. The interior features stunning art deco styling, complemented by the outdoor neon and stud-lit marquee with more than 700 lights. Note the only current change has been the replacement of the black reversed metal letters on the marquee with the current white milk glass (Courtesy of Richard Wolfe.)

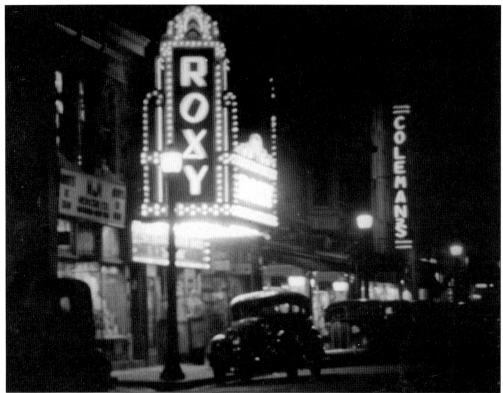

This is the only known nighttime photograph of the Roxy's marquee and uptown Northampton in the 1930s, before the marquee's 1970 restoration. (Courtesy of Richard Wolfe.)

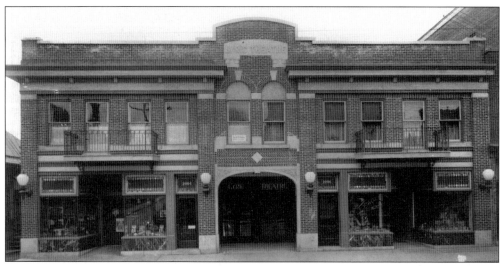

The Lyric Theatre, seen here c. 1930, was built in 1921 by Harry Hartman and now houses the Roxy Theatre. Miller Hardware, originally located to the left of the theater entrance, was later replaced by M&N Medicine, then Regal and Blum Jewelers, and currently Laufik's Jewelers. The Lyric News Agency and Seem's Barber Shop occupy the space to the right. (Courtesy of James Benetzky.)

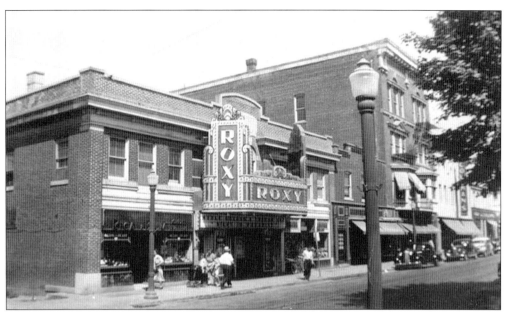

The Roxy Theatre building and Miller's are seen in the summer of 1946. Here, the Howell News Agency has now opened to the right of the Roxy entrance, with Regal and Blum to the left of the entrance. (Courtesy of Richard Wolfe.)

This c. 1925 photograph shows the Dr. Mahlon S. Miller House, at 2005 Main Street. Miller had his first medical office here before relocating to 21st Street. In later years, the building was occupied by Dr. W. H. Richards, a dentist, and then by the current occupant, Dr. Sydney Parmet.

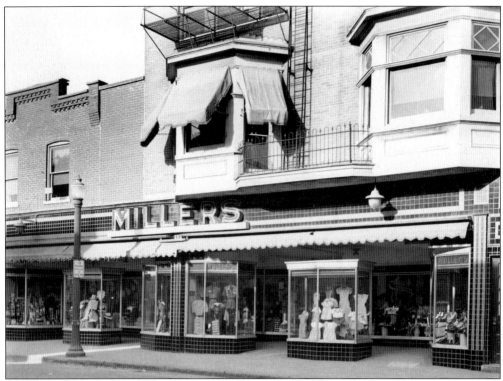

Miller's was located at 2010–2012 Main Street. The department store's facade is shown here in 1943. This photograph reflects the renovations made in 1941 to accommodate increased store traffic. (Courtesy of Robert Mentzell.)

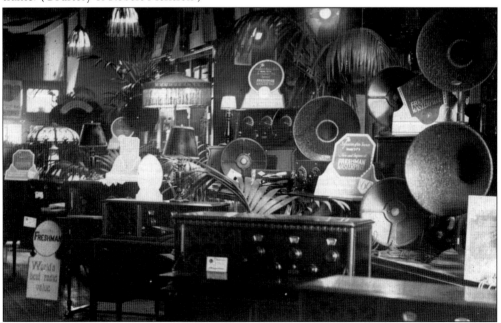

The Miller's radio department displayed these popular Atwater-Kent radios *c.* 1920. They were considered to be the best radios available at the time. (Courtesy of Robert Mentzell.)

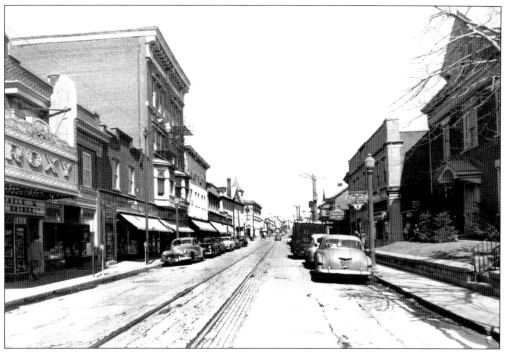
This c. 1950 view looks north down Main Street. This three-block area served the shopping needs of families from miles around.

The sporting goods department at Miller's is seen c. 1930. (Courtesy of Robert Mentzell.)

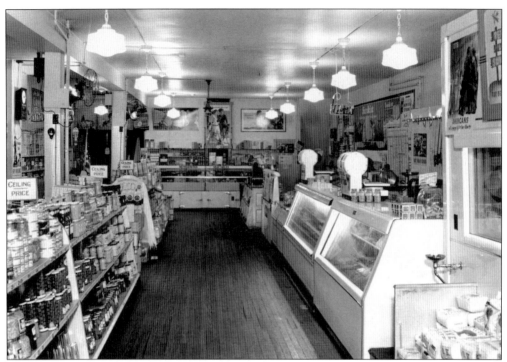

In this 1943 interior view of the Miller's grocery department, note the gaslight still visible in the center of the ceiling and the ceiling price signs reflective of the rationing due to World War II. (Courtesy of Robert Mentzell.)

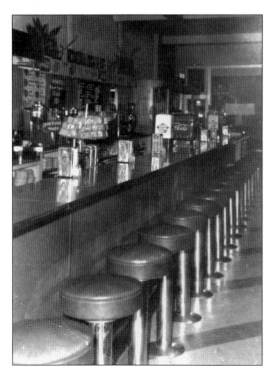

This early-1960s view of the counter space at the M&N looks toward Main Street. (Courtesy of Susan and Dale Sadler.)

Photographed in 1960, Coleman's, at 2014 Main Street, was nestled between Miller's to the south and J. J. Newberry's to the north. The department store was initially started in 1900 by Benjamin Coleman, making this the oldest retail establishment in the borough. Fred partnered with his father in 1935. (Courtesy of Fella Studios.)

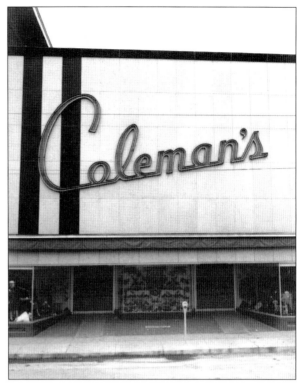

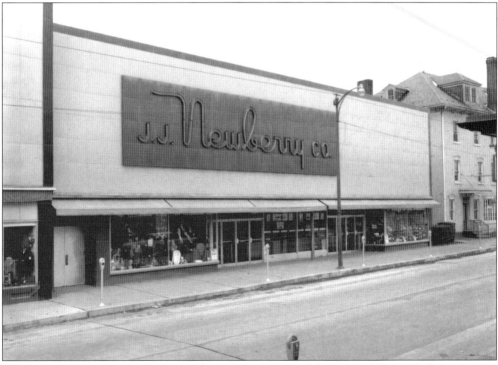

The J. J. Newberry Company, pictured in 1959, was one of the original five-and-dime stores in town, opening in the early 1920s. (Courtesy of Fella Studios.)

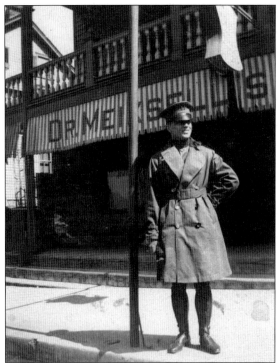

H. Kline Miller, bedecked in his World War I uniform, stands in front of Meixsell's, at 2023 Main Street, in 1918. This is the only known photograph of the drugstore's uptown location. This site later housed the Walker Pharmacy. Part of the A. S. Miller Funeral Home can be seen to the left of the drugstore. (Courtesy of Robert Mentzell.)

The Colarusso House is pictured c. 1935 on the southeast corner of 21st and Main Streets. Along with being a private residence, the building housed Champion Shoe Repair in its right front. The Allen House can be seen in the right background.

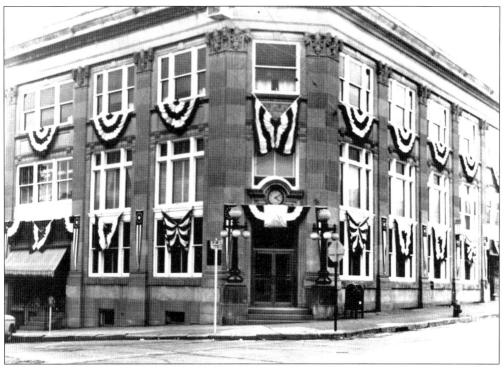

Seen c. 1948, the Cement National Bank, on the northwest corner of 21st and Main Streets, is all ready to celebrate. Constructed in 1922, this building also held, on its left side, Harry Seidel Clothes until 1945 and Frank DeLucia Men's Clothing from 1946, and on its right side, the Pennsylvania State Store.

The Allen House, built in 1870 by John H. Kleppinger, is pictured here c. 1947. Located at the southwest corner of 21st and Main Streets, it continued to be a popular boardinghouse and restaurant. Note the Berg Mansion in the right background. (Courtesy of the Morning Call.)

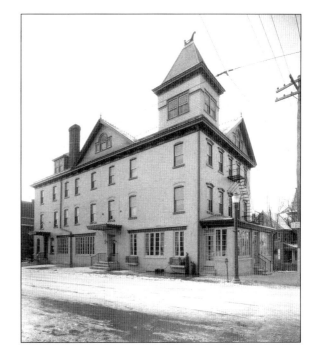

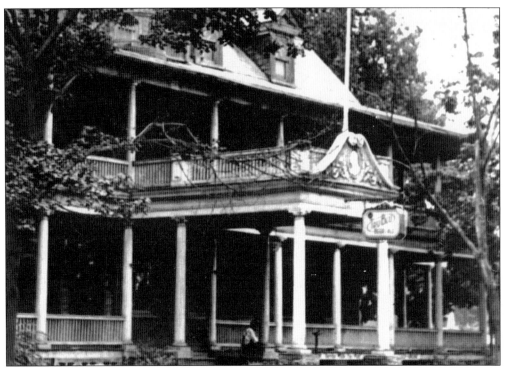

This southeastward view of the Mount Vernon Inn was captured c. 1940. Note the Tru-Blu sign hanging from the porch.

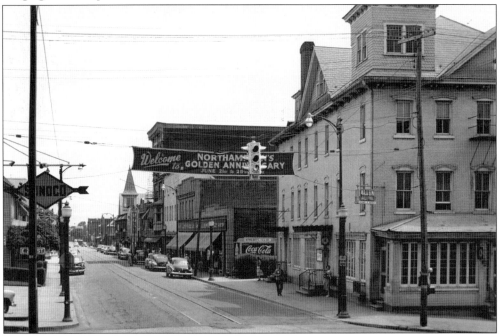

The Allen House and Main Street are seen in this southward view from just north of 21st Street. The photograph was taken during the borough's 50th anniversary celebration in May 1952. (Courtesy of Carol Simcoe.)

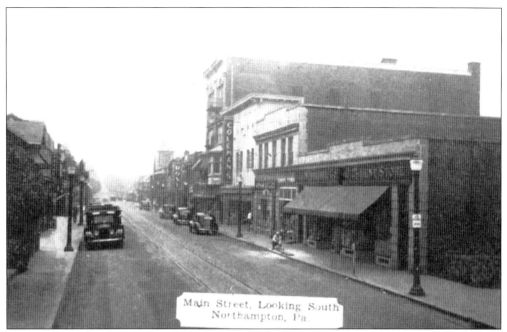

Looking south from 21st Street, this 1930s view shows the business district. Around this time, the J. J. Newberry building also housed the businesses of Tony Sinatore, a fruit vendor who later relocated to 1718 Main Street with his son Pat, and tailor Saul Kivert, who later founded Tama Manufacturing at 1798 Main Street in 1946. (Courtesy of Art Brown.)

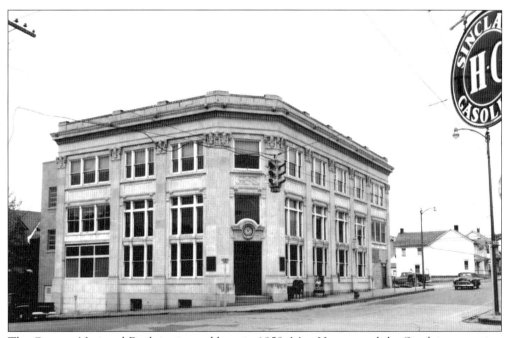

The Cement National Bank is pictured here in 1959. Max Hess owned the Sinclair gas station in the right foreground, where a rare glimpse can be made of the Sinclair sign. To the left of the bank, a portion of the Dr. Miller House is visible. (Courtesy of Fella Studios.)

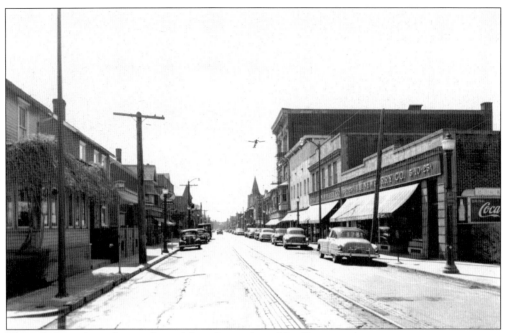

This 1949 southward view shows Main Street from 21st Street.

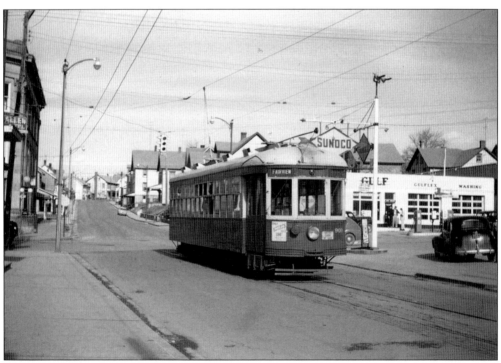

In November 1953, the trolley at 21st and Main Streets prepares to make a trip back to downtown Allentown. In the background is Harhart's Service Station, along with owner John Harhart. The gas station, opened on March 1, 1947, as a two-bay garage, stands on the property formerly occupied by the Mount Vernon Inn.

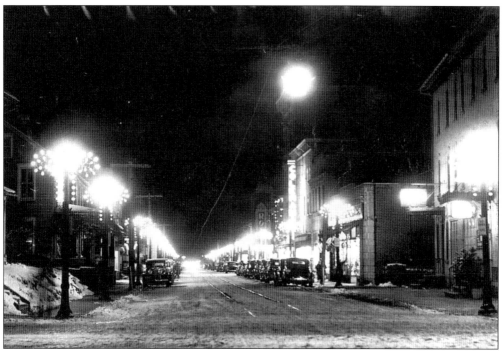

Uptown at night is captured in this beautiful view of the 2000 block of Main Street, looking south from 21st Street, during the Christmas shopping season in the early 1940s. Shopper traffic uptown on a Friday night or Saturday morning was comparable to big-city shopping. In its heyday from the 1920s to the 1940s, Northampton's uptown was the second-busiest shopping district in the Lehigh Valley.

This southward view of Main Street was taken from 21st Street in 1976.

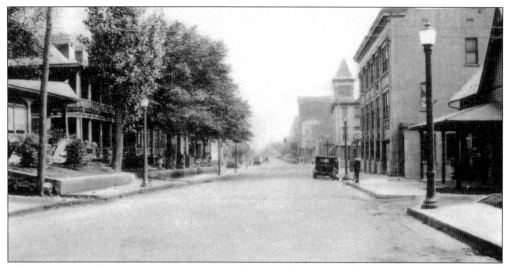

Taken c. 1925, this view of Main Street looks south just above 21st Street. Note the Mount Vernon Inn to the left and, just across the street to the right, the Cement National Bank. Featured to the far right side is the building that housed Edmund Reitz Jewelers in the 1930s and barber Carl Roth in 1943. (Courtesy of Ralph Hoffman.)

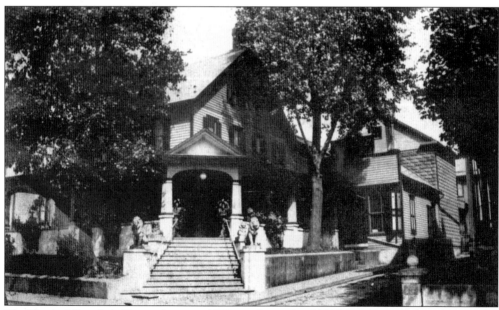

The Howard Cramlich House, shown c. 1922, was located at 2121 Main Street. It later became the Golden Lion Inn. The lions are still present on the front steps today. (Courtesy of Ralph Hoffman.)

Five
OUR TOWNSPEOPLE, ALL NEIGHBORS

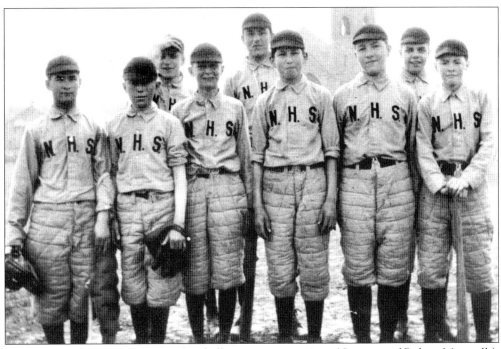

Northampton High School's first baseball team poses in 1911. (Courtesy of Robert Mentzell.)

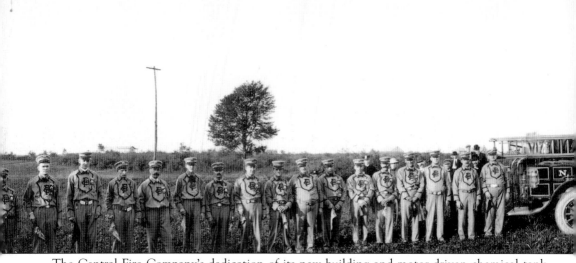

The Central Fire Company's dedication of its new building and motor-driven chemical tank and hose apparatus occurred on October 14, 1911. Many of the firemen were musically gifted

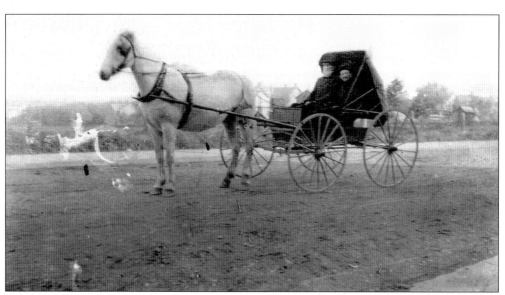

Tobias and Harriet (Dory) Smith pose *c.* 1913 with their white horse and buggy along Howertown Road, now 10th Street, where they resided. (Courtesy of Harold P. Smith.)

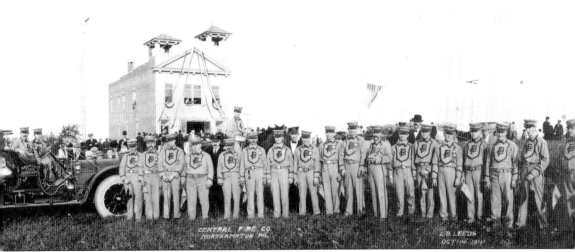
and also performed in the company band, as shown in this photograph.

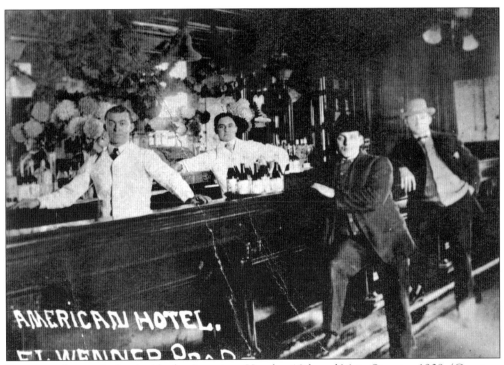
Patrons gather at the bar inside the American Hotel at 10th and Main Street c. 1908. (Courtesy of Art Brown.)

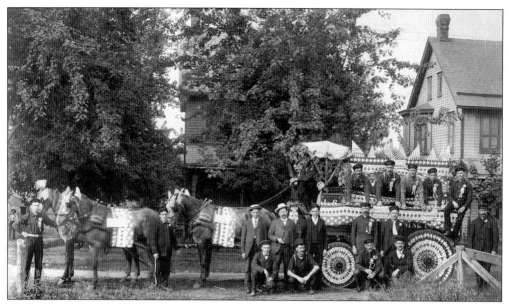

This c. 1915 patriotic float advertises Northampton pilsner beer by the employees of the Northampton Brewing Company. The photograph was taken on Newport Avenue. The house behind the clump of trees was owned by Samuel Laubach. (Courtesy of Raymond E. Holland.)

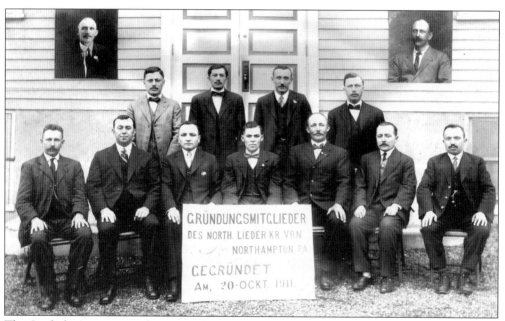

The Liederkranz, organized on October 20, 1911, has been located at its current address, 402 East Ninth Street, since 1914. The mission of the Liederkranz is to cultivate the knowledge of German folk music and to promote the good customs of the former homeland. The founding fathers are pictured in 1911. From left to right are the following: (first row) Peter Weiss, John Klingaman, John Gerbasitz, John Kurta, president Stephen Klepiss, secretary Julius Kovacs, and Louis Messenlehner; (second row) Frank Sharkazy, Joseph Sharkazy, Martin Einfalt, and George Keppel.

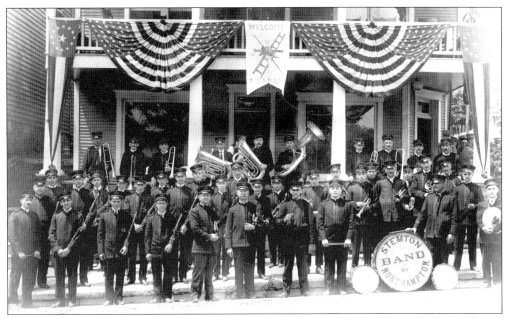

The Stemton Band poses for a photograph c. 1911. Organized in 1880, the band enjoyed one of the finest reputations in the Lehigh Valley. It was incorporated as the Stemton Band of Northampton on October 17, 1910. Rehearsals were at one time held in the American Hotel, at 10th and Main Streets. This photograph was likely taken on the porch of a building, since torn down, next to the Alliance Fire Company after a fireman's parade in 1911. Note the Central Fire Company Band, also shown on page 106, standing in the right background.

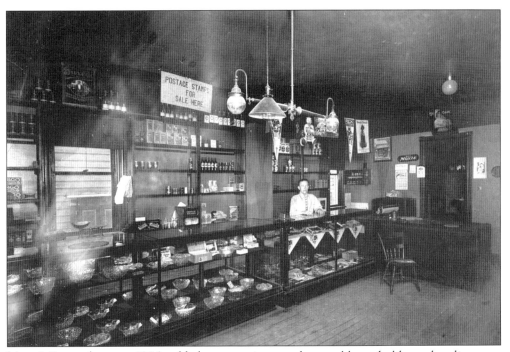

Moser's Store, shown c. 1916, sold glassware, cigars, and general household merchandise.

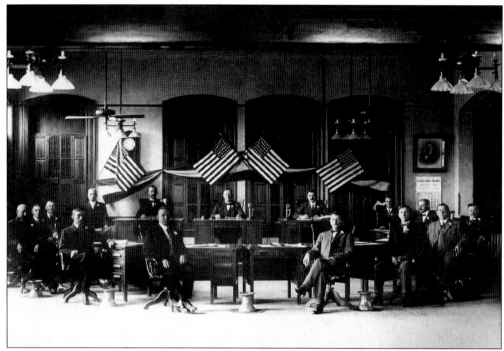

A Northampton Borough Council meeting is under way in October 1913. The council met on the second floor of the municipal building. Note the gaslights still in use at that time. (Courtesy Gene Zarayko.)

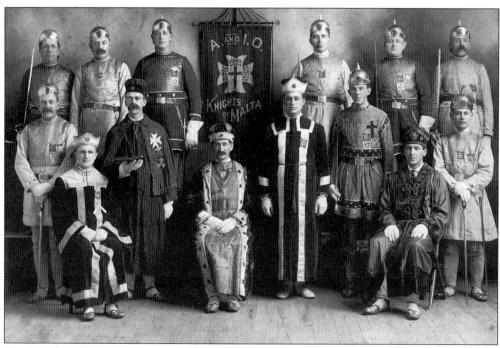

The Knights of Malta are shown in this c. 1910 photograph.

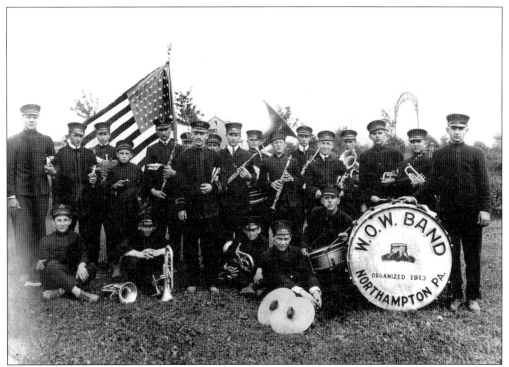

Members of the Woodmen of the World Band pose for a photograph c. the 1920s. The fraternal band organized in 1913. (Courtesy of Gene Zarayko.)

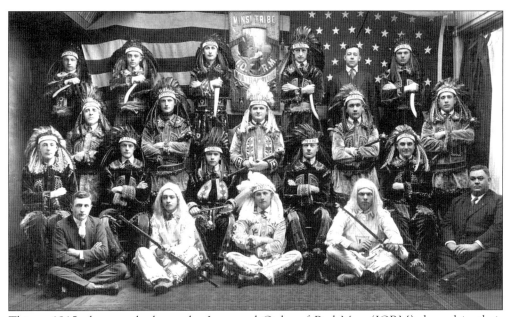

This c. 1915 photograph shows the Improved Order of Red Men (IORM) dressed in their Native American regalia. The Minsi Trail Tribe No. 357 met in Grey's Hall, now a residence at 732–734 Washington Avenue.

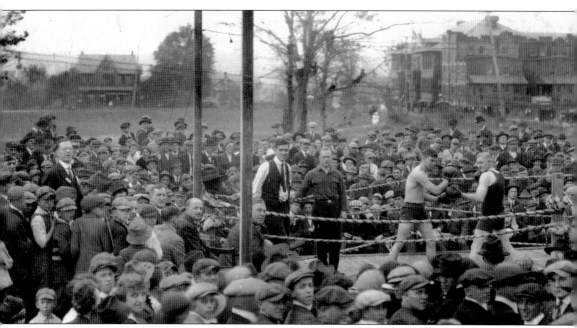

The welcome home celebration was held on October 16 and 17, 1919. As part of this two-day event for local doughboys returning from World War I, Northampton sponsored five boxing bouts featuring local boys Johnny "the Siegfried Bearcat" Herman and Young "the Pride of Northampton" Leonard. The matches were staged by Charles Ettinger. The largest parade ever held in the borough covered the main roads. A huge dinner for veterans, a memorial service, a

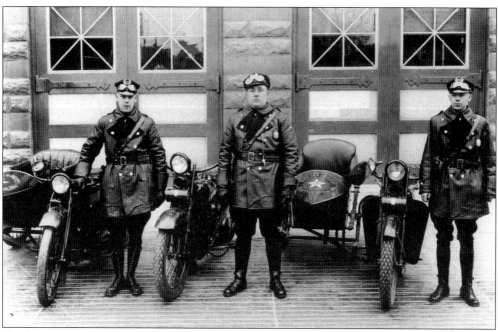

Northampton's first motorcycle police force is shown in this c. 1923 photograph. The only person identified is Edward Eck, the officer on the far right. (Courtesy of Gene Zarayko.)

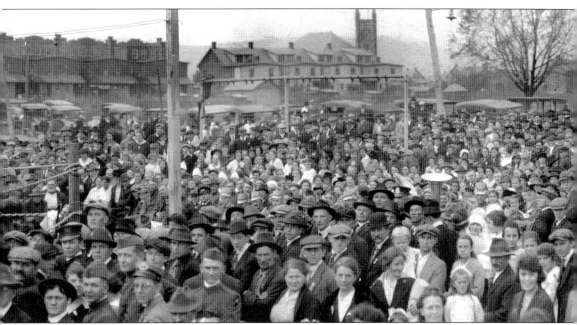

Northampton-versus-Catasauqua baseball game, and fireworks rounded out the festivities. This view is looking northwest from Laubach Avenue at 18th Street on today's Northampton Athletic Association fields. The row of homes in the background, on the 1800 block of Lincoln Avenue, was known as Silk Stocking Row because the homes were considered upscale at that time. (Courtesy of Jack Guss.)

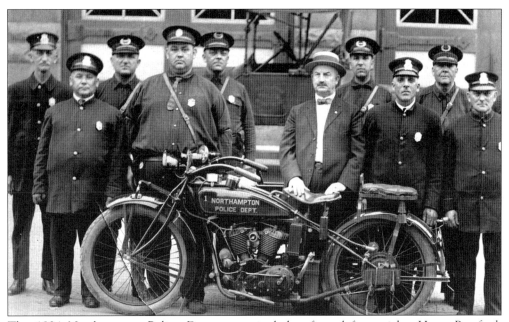

The 1924 Northampton Police Department includes, from left to right, Harry Bamford, unidentified, Howard Benvenuti, Chief James Hiestand, Millard Frantz, Burgess William Easterday, Raymond Spengler, Titus Brownmiller, Walter Hepner, and Ed Gardner. Missing from the photograph is Michael Susko.

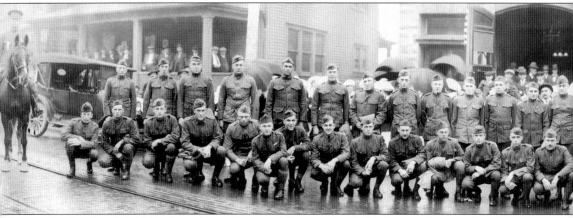
On October 16, 1919, the welcome home celebration was held. Seen in front of the municipal

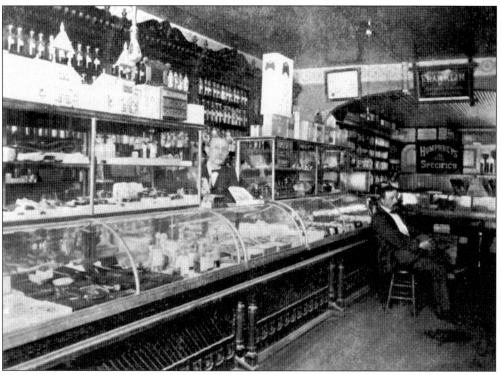
This *c.* 1903 photograph shows an interior view of Yale's Drug Store in Siegfried. As advertised, it was "the old reliable place for drugs, stationery, and souvenir cards."

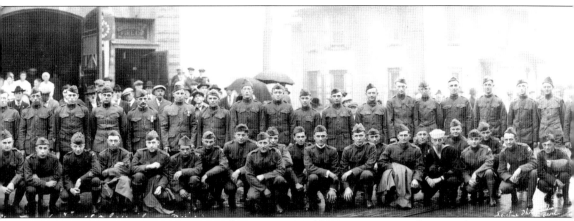

building at 1516 Main Street are Northampton's World War I veterans who served overseas.

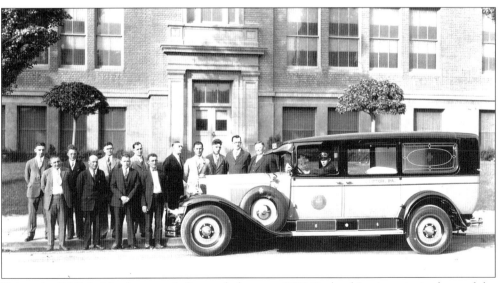

Driven by Ed Eck, Northampton's first ambulance, a 1928 Packard Legion, sits in front of the Wolf School building. From left to right are the following: (first row) ? Schadler, Harry Rabenold, unidentified, and Howard Rabenold; (second row) Paul Bachman, E. A. Boyer, Russel Kern, Lester Yeager, Ed Fogel, John Rossi, unidentified, A. Kistler, and Monroe Miller Sr.

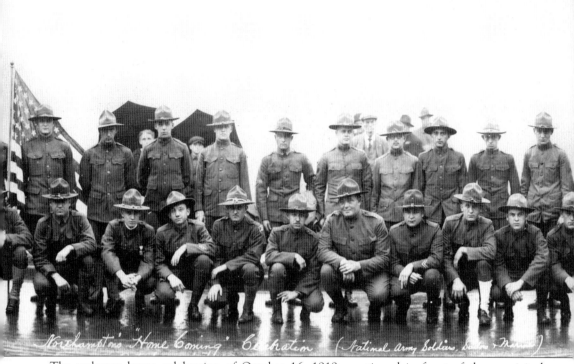

The welcome home celebration of October 16, 1919, continued in front of the municipal building at 1516 Main Street, as Northampton's World War I veterans who served stateside

Frank Keller Sr. and Frank Keller Jr. proudly pose with their new fleet of trucks in 1931. The fleet consisted of a 1928 Hahn Highlift and a 1928 Stake Body Ford. Keller's Coal Yard is still located at 507 Washington Avenue. (Courtesy of Frank Keller Jr.)

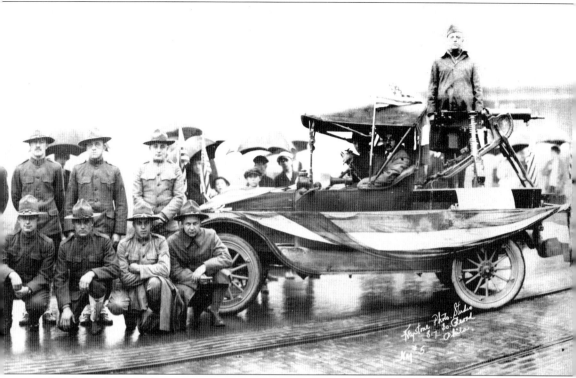

gather for a photograph.

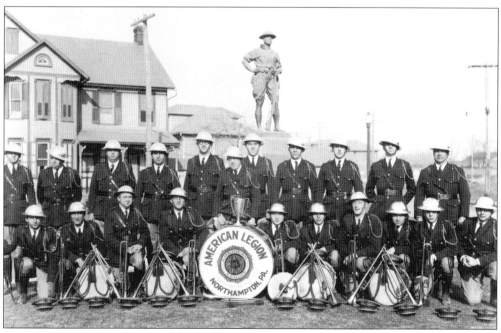

The American Legion Drum and Bugle Corps appears in 1928 with its newly won trophy at the Northampton Memorial Plot, at 14th and Washington Avenues. (Courtesy of Gene Zarayko.)

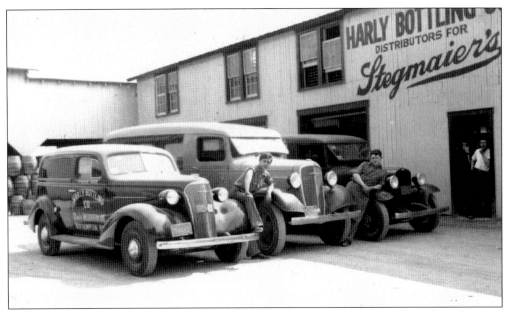

The Harly Bottling Company, located at the southwest corner of 22nd Street and Washington Avenue, owned a fleet of trucks, as seen in this 1940 photograph. Ed Lilly and Harry Hartman started the company in 1939 after Hartman sold the Lyric Theatre. In 1965, the business was sold and became the Simcoe Beverage Company. (Courtesy of Carol Simcoe.)

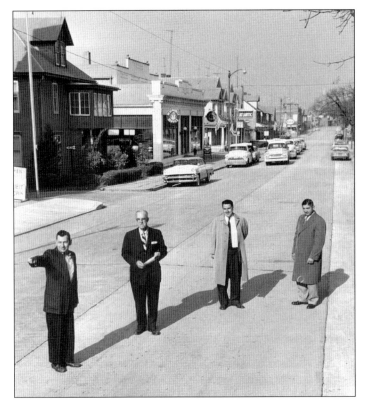

Borough officials were eager to make improvements to Main Street in 1955. Pictured are, from left to right, Ray Wahl, Hale Guss, Stanley Skrocki, and Metro Korutz. In the background, one can get a glimpse of the Lentz Motor Company, at 1540 Main Street.

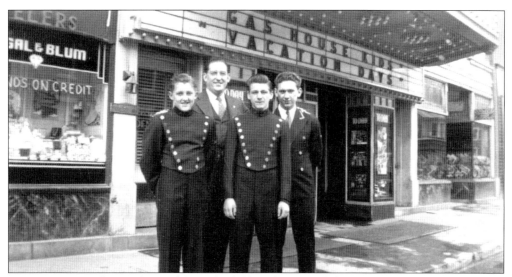

Roxy manager Bill Sage (second from the left) is shown with his ushers in front of the theater in 1946. Visible in the background are Regal and Blum Jewelers (left) and the Lyric News Agency (right). (Courtesy of Randi Sage.)

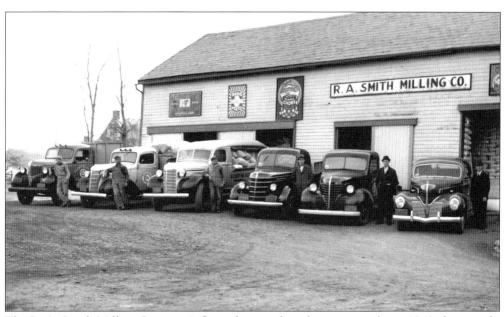

The R. A. Smith Milling Company's fleet of cars and trucks is seen in this c. 1948 photograph. (Courtesy of Edward Pany.)

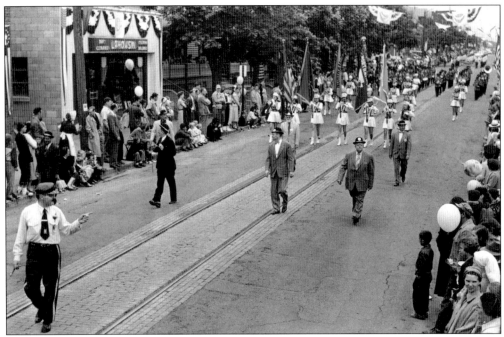

This parade commemorated the borough's 50th birthday. Leading the parade as it reaches 17th and Main Streets is Northampton burgess and parade chief marshal William Anthony. Note Lahovski's Cleaners on the left. (Courtesy of Carol Simcoe.)

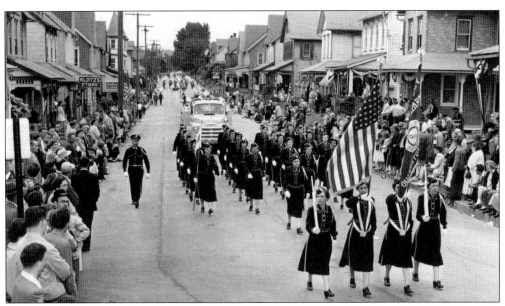

The 1952 parade commemorating Northampton's 50th anniversary marches down Washington Avenue at 17th Street in this northward view. Klotz's Bakery (left) was known for its tasty cream puffs. In those years, parades in Northampton marched up Main Street from Laubach Avenue to 21st Street, then back down Washington Avenue to the Memorial Plot at 14th Street. (Courtesy of Carol Simcoe.)

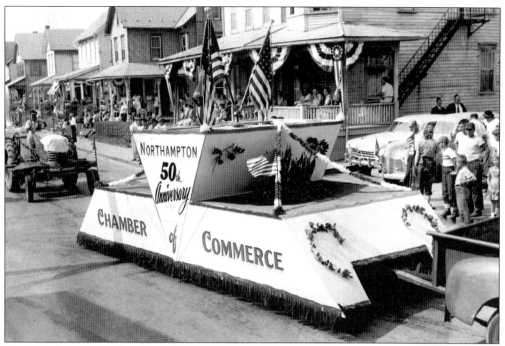

The Northampton Chamber of Commerce float is seen in the 50th anniversary parade at 17th Street and Washington Avenue. Started in July 1929, the Northampton Area Chamber of Commerce still serves the area business community as an advocate and facilitator of local commerce and business-related events and education. (Courtesy of Art Brown.)

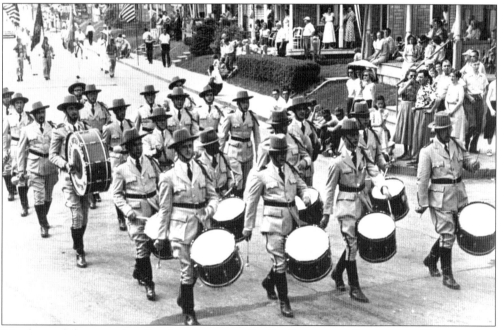

Members of the American Legion Drum and Bugle Corps sport their new uniforms as they march down Washington Avenue in the 1952 parade. (Courtesy of Gene Zarayko.)

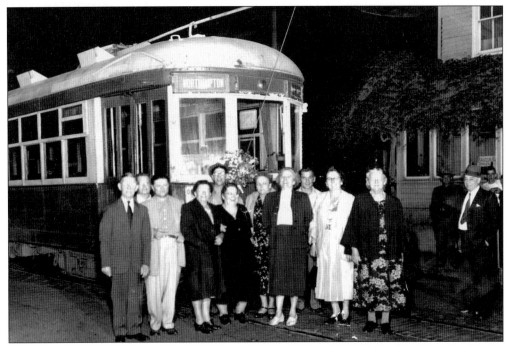

This photograph was taken at the "end of the line," figuratively and literally, at 21st and Main Streets at 1:30 a.m. on May 11, 1953, as a crowd of well-wishers prepares to send the trolley on its way back to Allentown. The death knell for the local trolley came when Route 22, Lehigh Valley's new four-lane highway, cut across the rails in Fullerton, making service to points south unprofitable. (Courtesy of Edward Pany.)

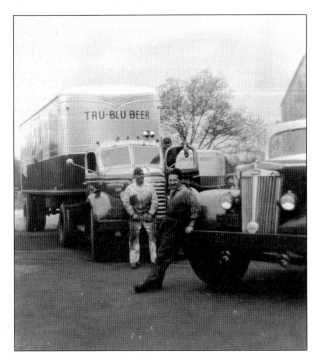

This truck was a part of the Tru-Blu fleet that delivered the popular beer to stores and distributors in the Northeast. (Courtesy of Gene Zarayko.)

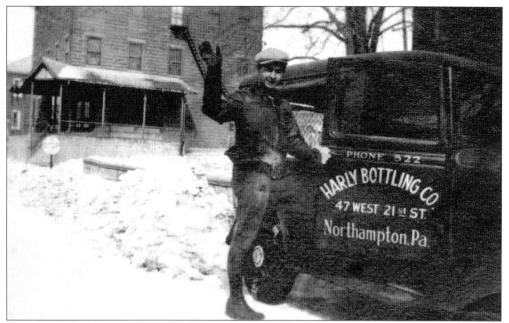

Jack Hartman, future owner of Jack's Lunch, on Main Street, makes a delivery at 21st Street and Washington Avenue in 1954. The structure behind him is the Odd Fellows building, later torn down to allow for the parking lot at the Schisler Funeral Home. (Courtesy of Ralph Hoffman.)

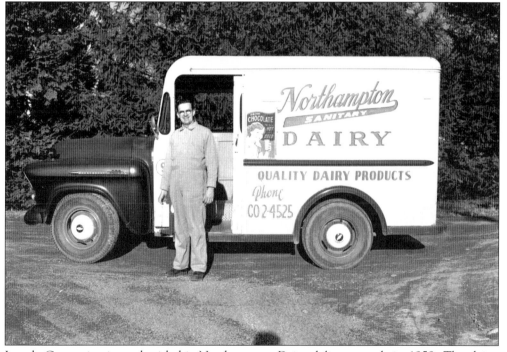

Joseph Gasper is pictured with his Northampton Dairy delivery truck in 1959. The dairy, founded in 1925 by John Simcoe, was located at 931 Washington Avenue. It was later purchased by the Lehigh Valley Farmers Cooperative in 1960. (Courtesy of Edward Pany.)

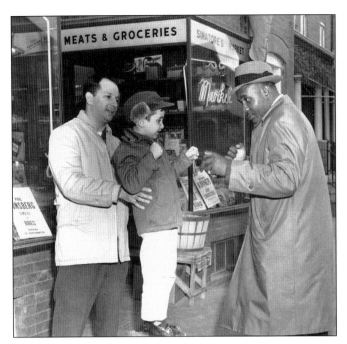

A young Perry Sinatore spars with heavyweight boxing champion Sonny Liston in 1961, ably assisted by his father, Pat Sinatore, in front of Tony's Market, at 1718 Main Street. Begun by Tony Sinatore in 1936 after moving his fruit stand from uptown's J. J. Newberry's, Tony's Market was a popular neighborhood grocery store. His son Pat took over the market in 1962. (Courtesy of David Rank Jr.)

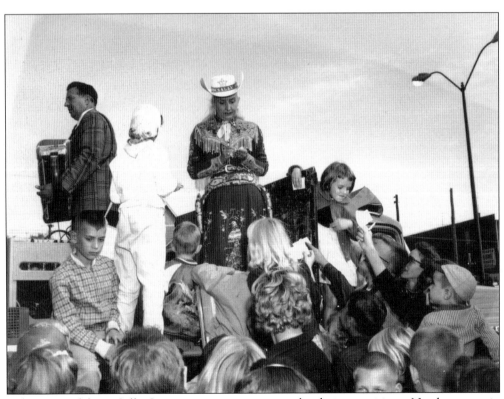

Television celebrity Sally Starr stops to sign autographs during a visit to Northampton in November 1960. (Courtesy of Fella Studios.)

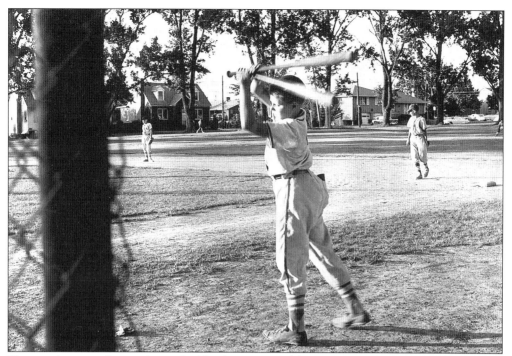

This northeastward view shows the Northampton Athletic Association baseball field in 1965 as a future Northampton All-Star prepares for his Big League ascent. Note the sycamore trees in the background, which once completely outlined the property. (Courtesy of David Rank Jr.)

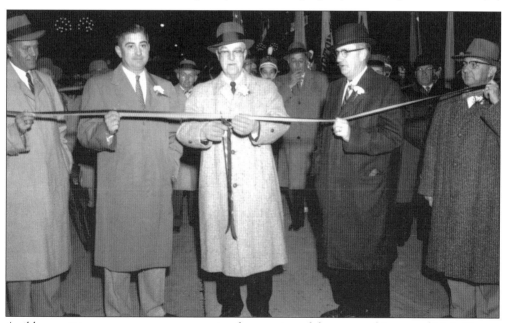

A ribbon-cutting ceremony commemorates the opening of the new and improved Main Street. The removal of the antiquated trolley tracks precipitated the repairing and re-paving of the street. Mayor Hale Guss (center) presides over this November 1959 event. For a related photograph of the construction, turn to page 87. (Courtesy of Fella Studios.)

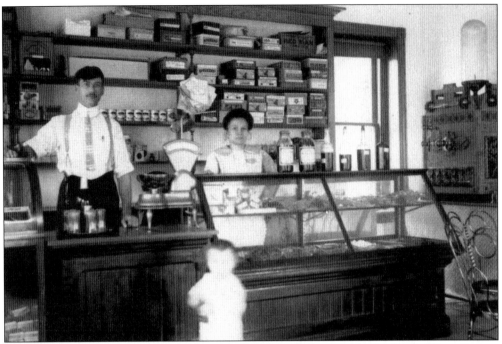

This 1916 photograph provides a look inside the sweet shop owned by Stefan and Erma Luisser at 1756 Main Street. The couple sold homemade candy, soda, and ice cream, all visible here. Note the wall on the right, with the first automated Coca-Cola dispenser and original wrought-iron chairs. The exterior photograph can be seen on page 74. (Courtesy of Stephen Luisser.)

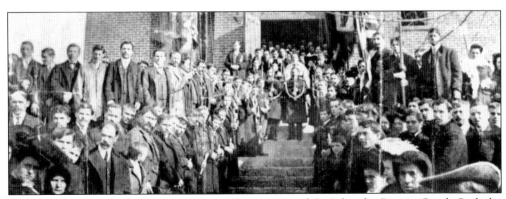

Early parishioners of Ukrainian and Slavic descent attend St. John the Baptist Greek Catholic Church in Newport during the 1905 celebration of the Blessing of the Water on the Feast Day of Jordan. (Courtesy of Peter Krywczuk.)

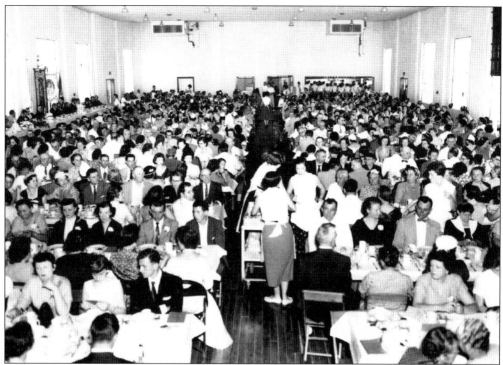

The Northampton Memorial Community Center serves more than 750 at the 1957 banquet for the Our Lady of Hungary Church. This banquet hall and community center was the former Atlas Cement Bag Factory and Printery shown on page 34. (Courtesy of Fella Studios.)

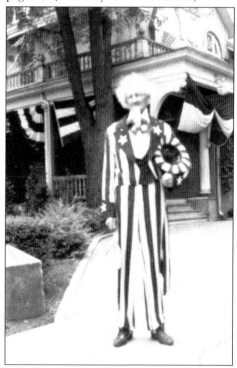

A Fourth of July celebrant, possibly Noah Weiss, is shown c. 1925 in the driveway of the Mount Vernon Inn, at 21st and Main Streets.

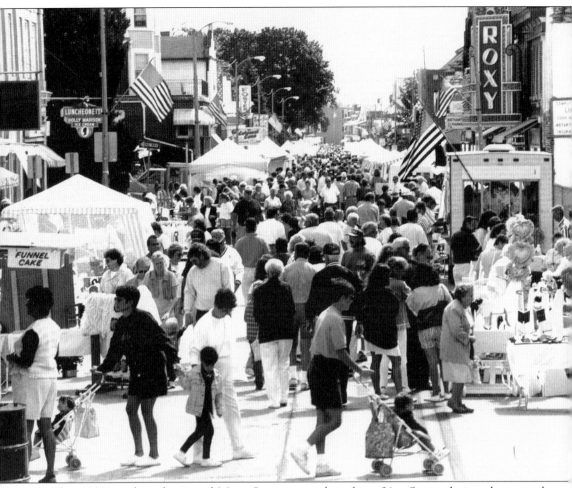

This 1998 southward view of Main Street was taken from 21st Street during the annual Northampton Street Fair, sponsored by the Northampton Area Chamber of Commerce. The fair is held the second weekend in September, attracting thousands who celebrate community with craft and food vendors, bands, street entertainers, and, most importantly, townspeople just enjoying each other's company in this fine town we call home. It is just as our forefathers would have wanted it.